Design has been designed using resources from Freepik.com

61 big mandala designs with thick lines and large spaces to easily color for relaxing fun.

By Najib bakchich

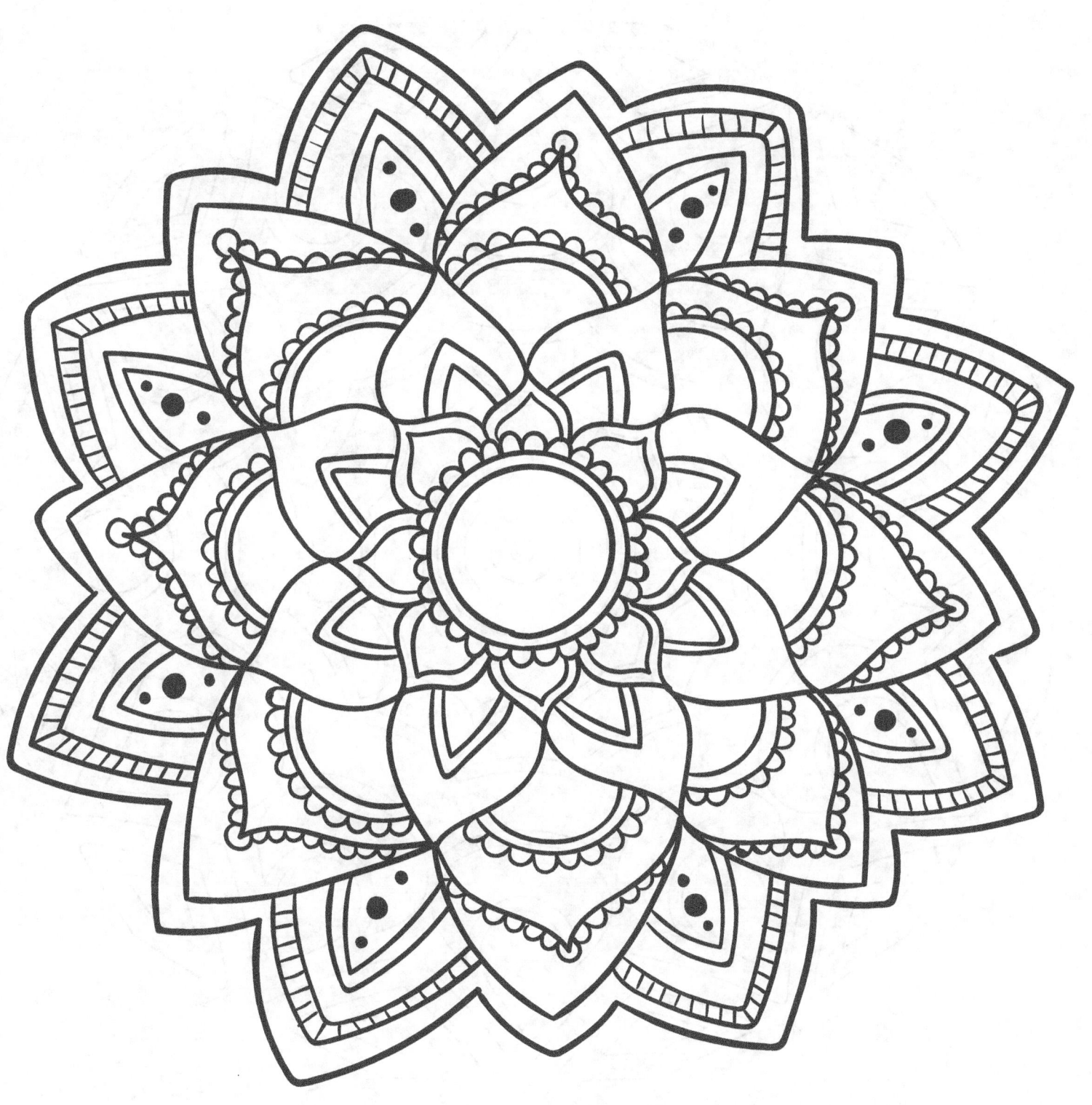

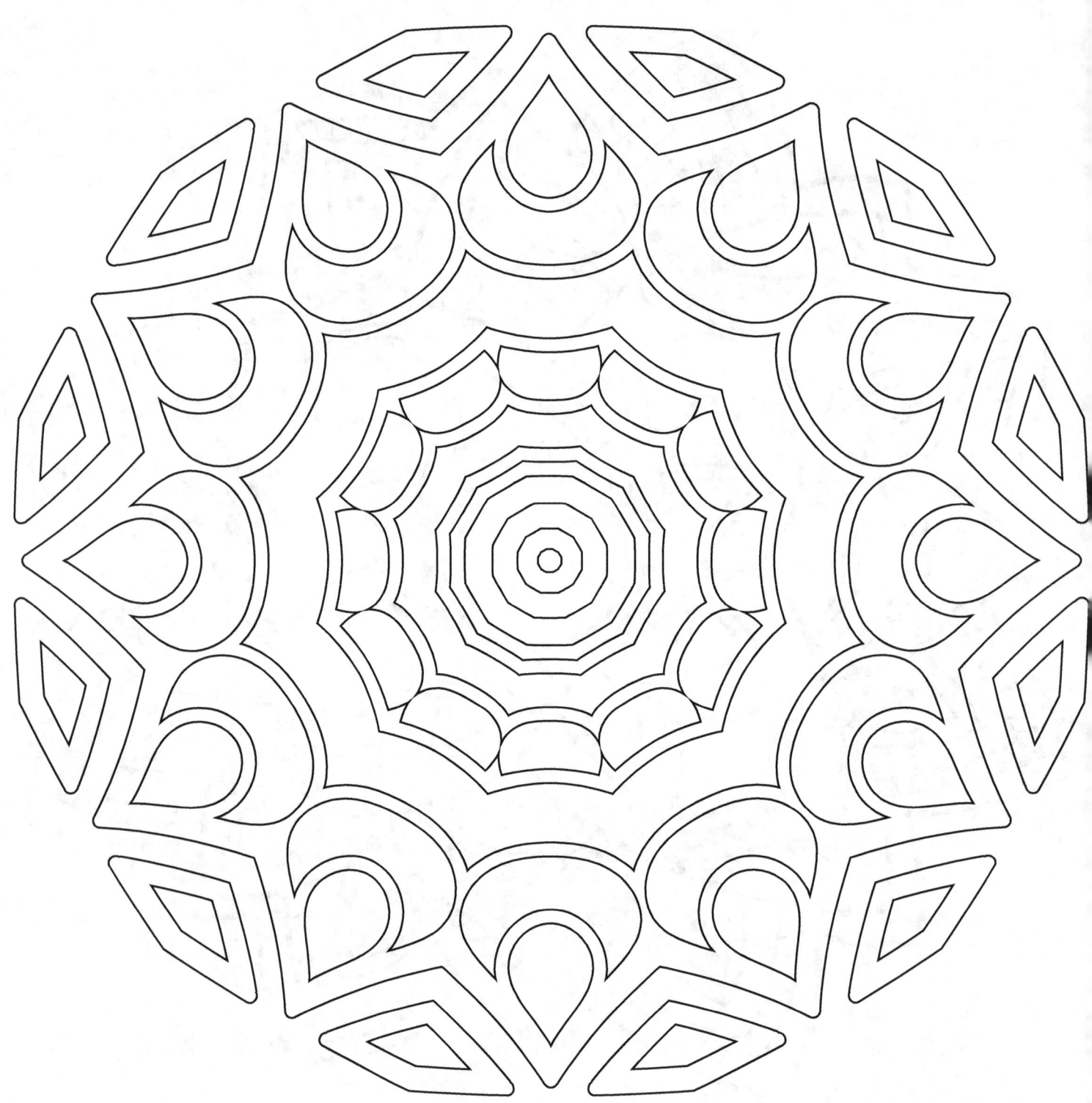

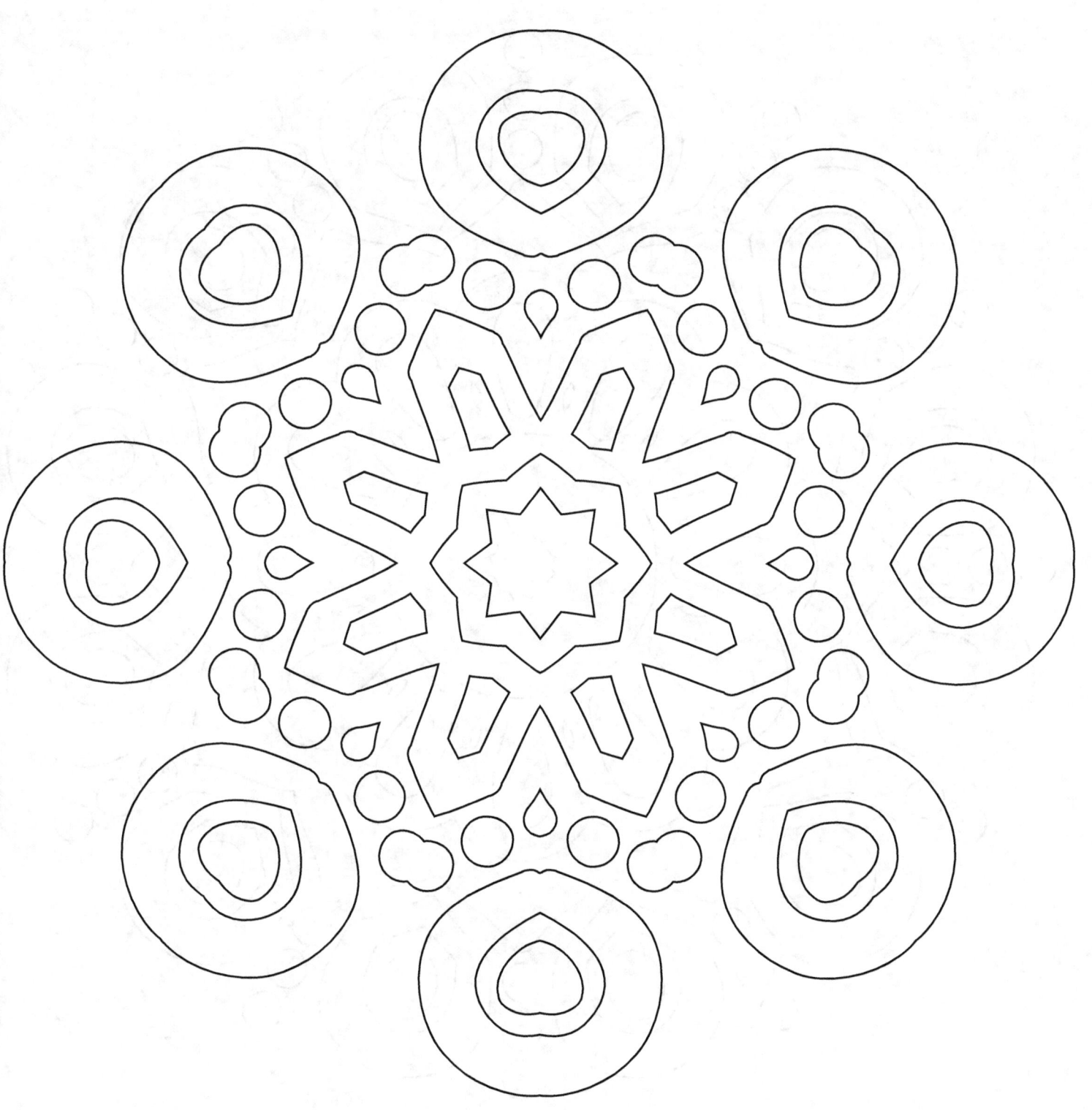

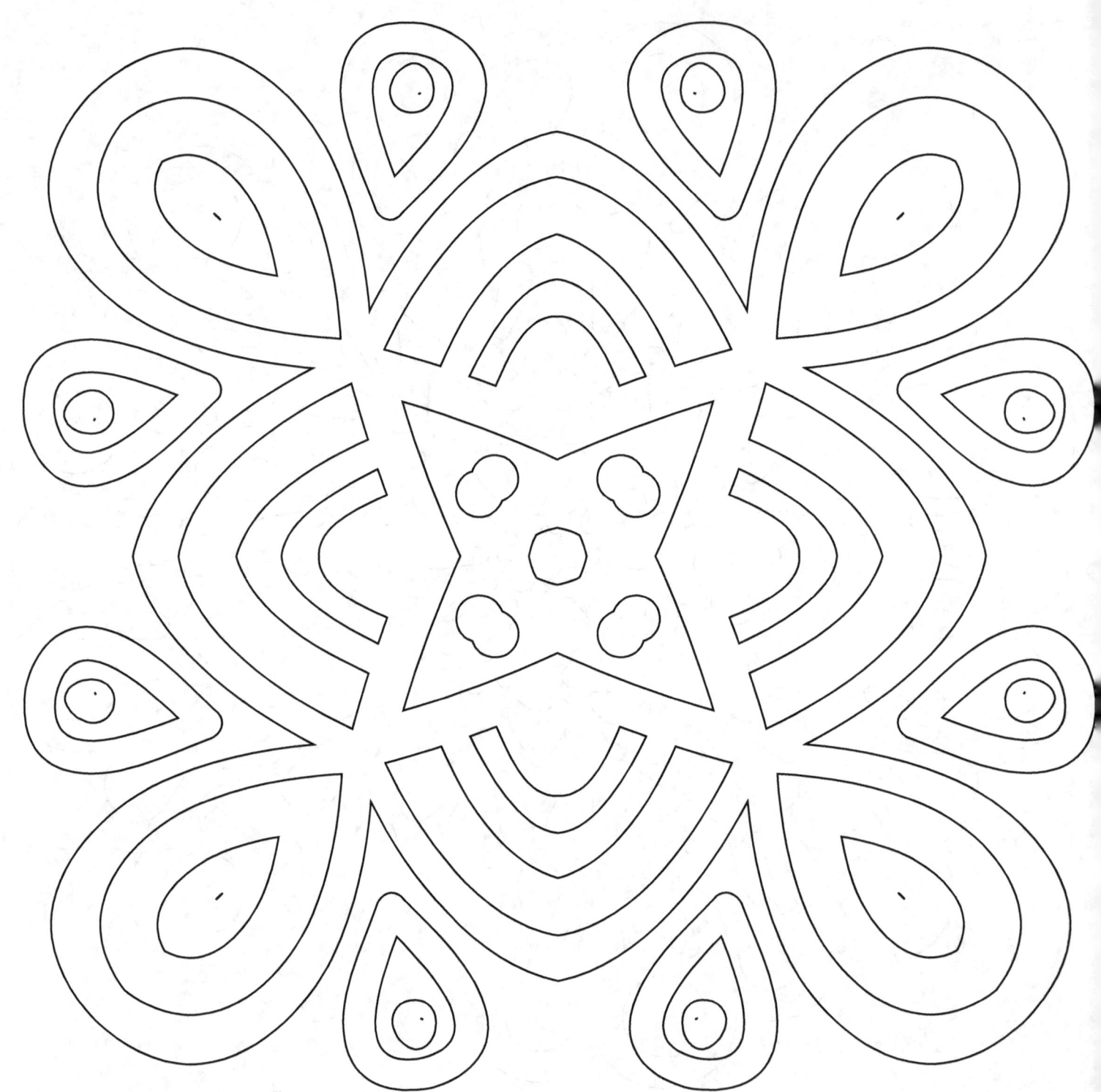

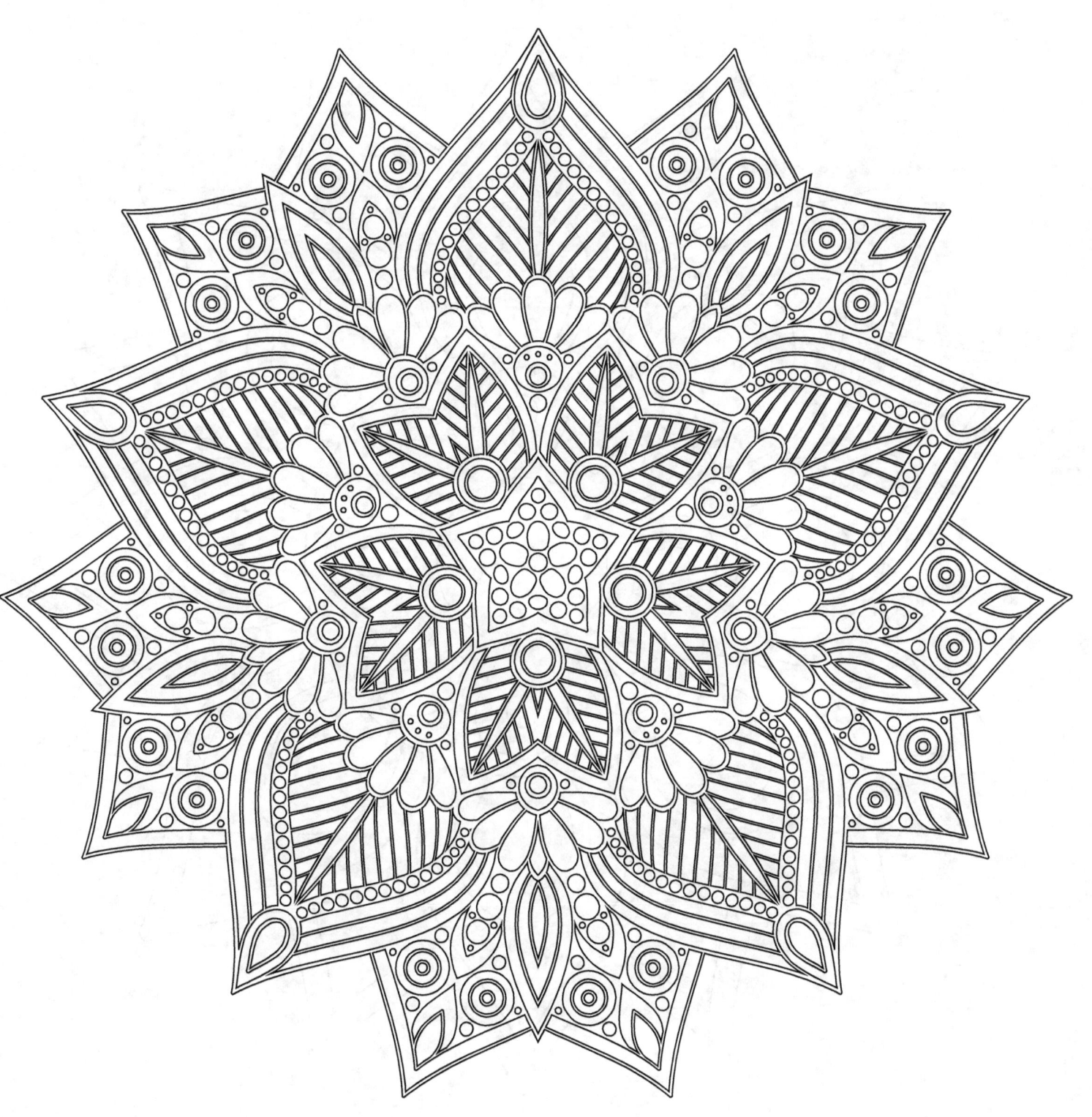

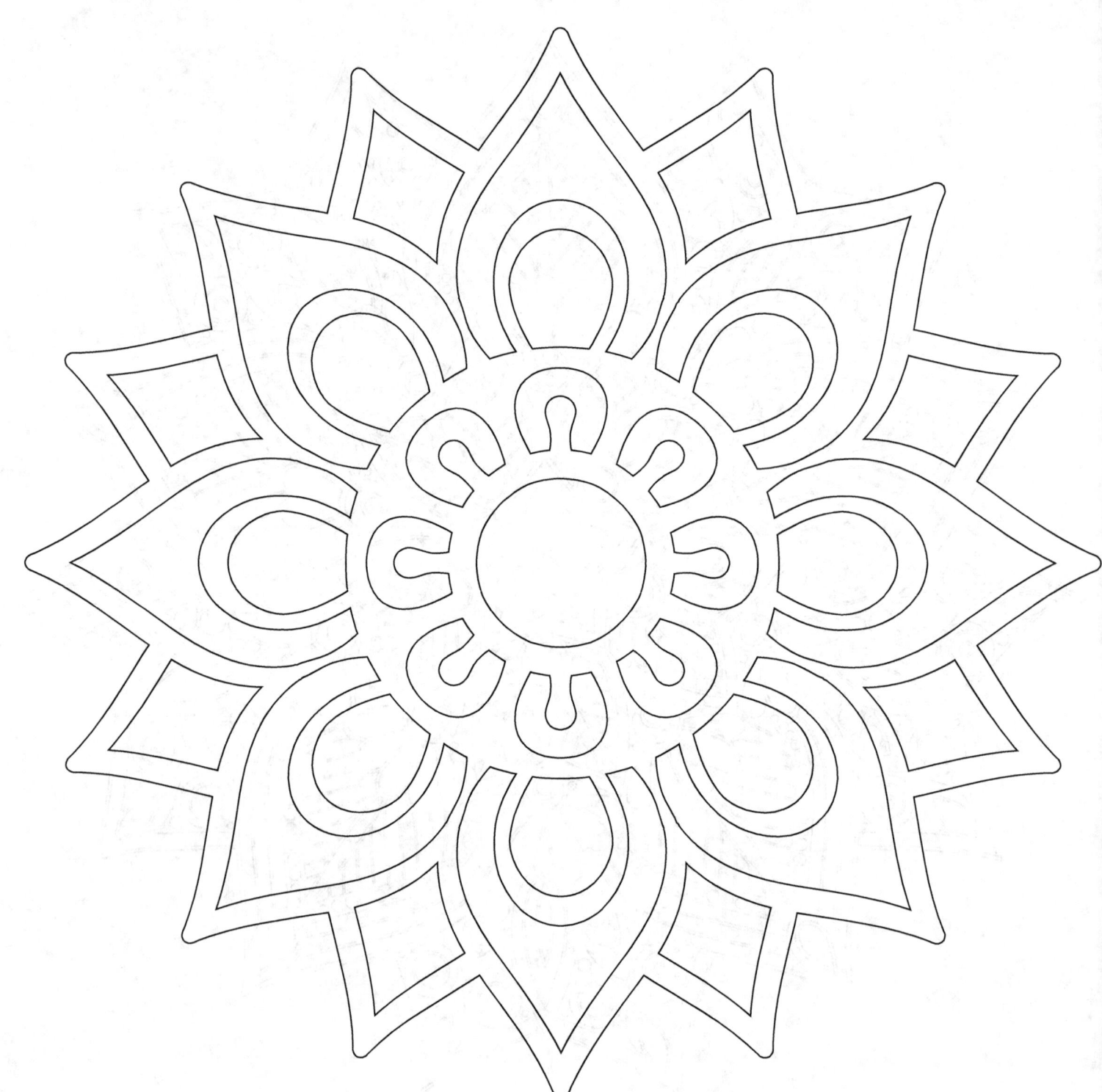

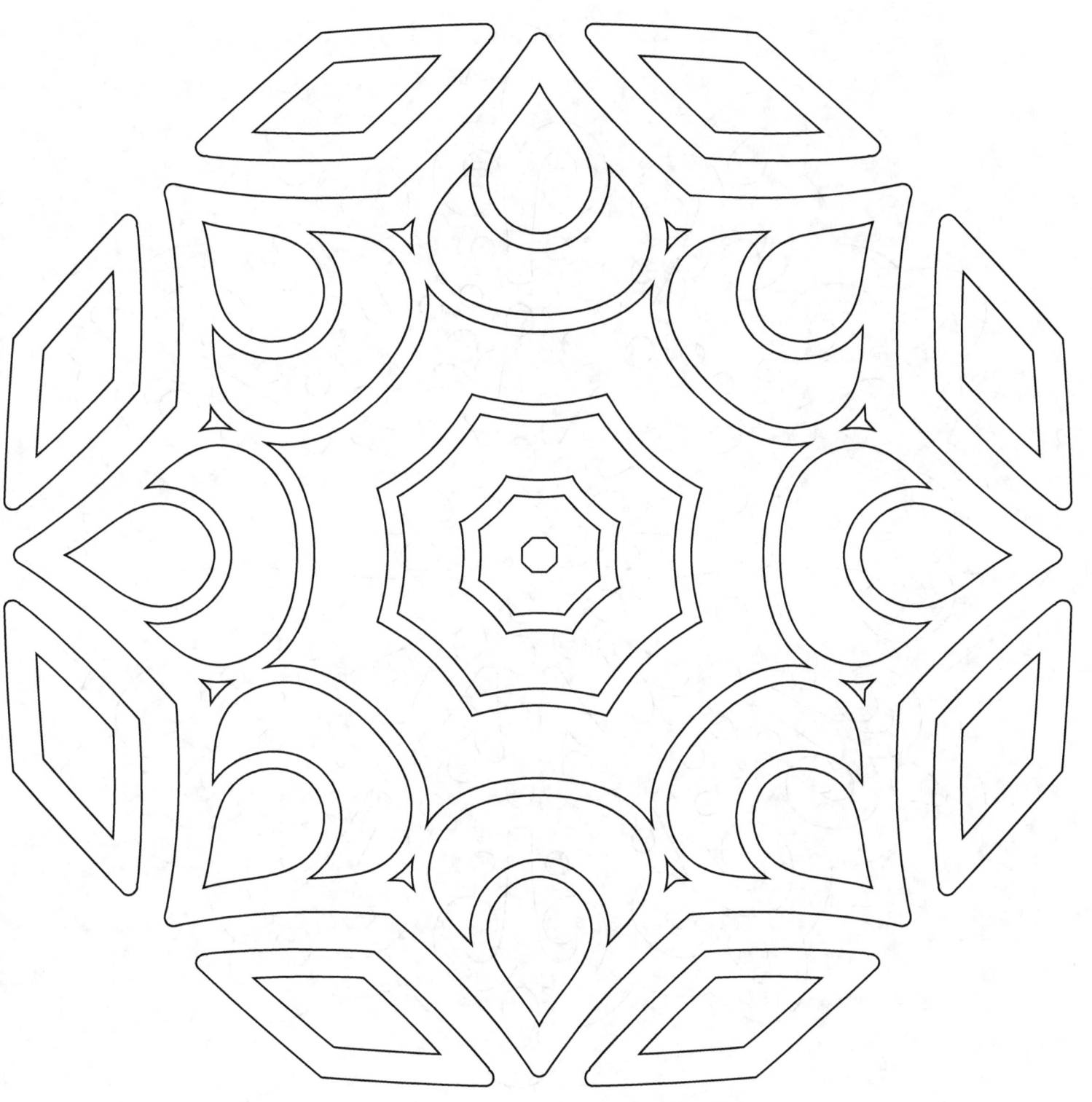

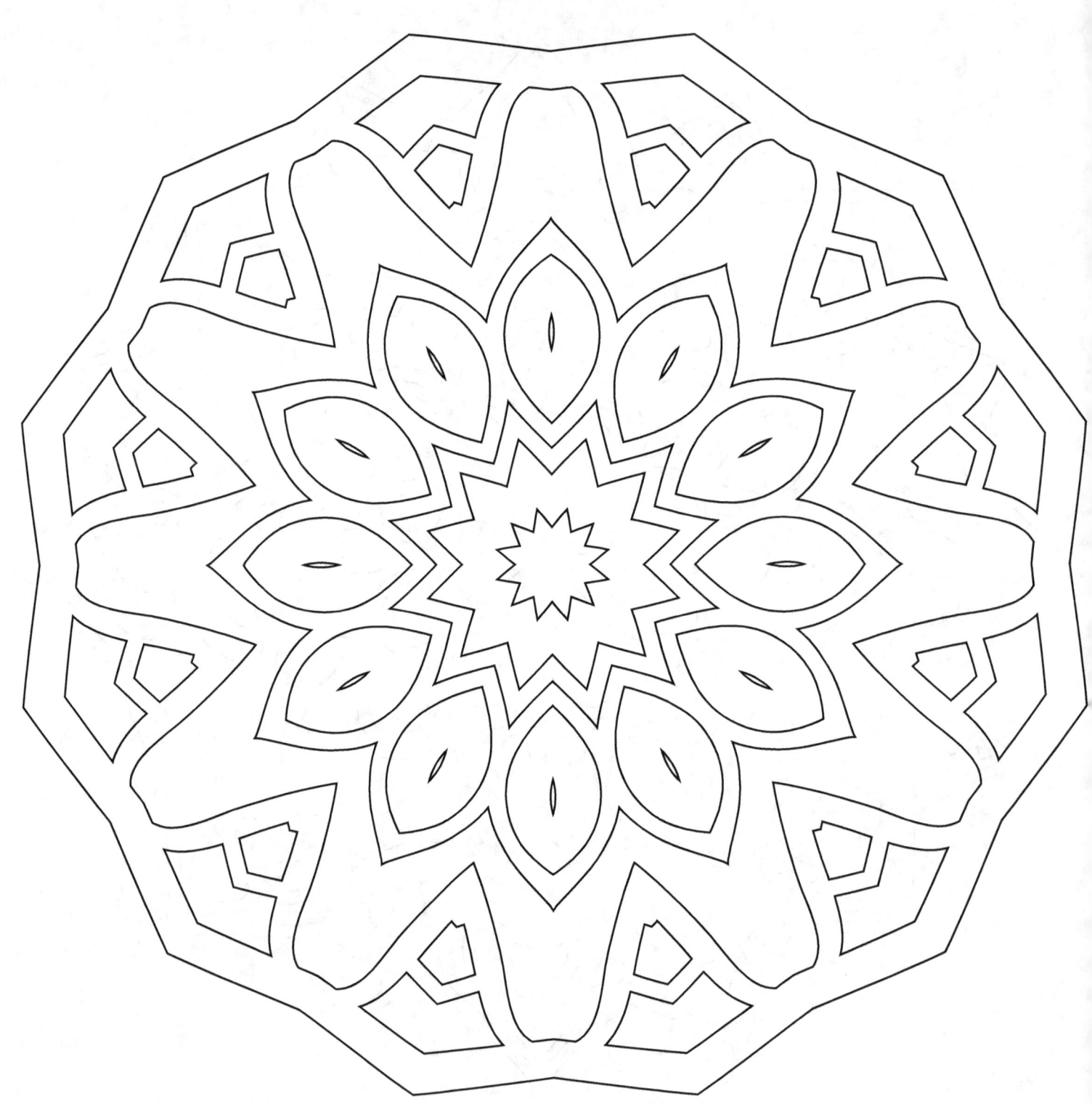

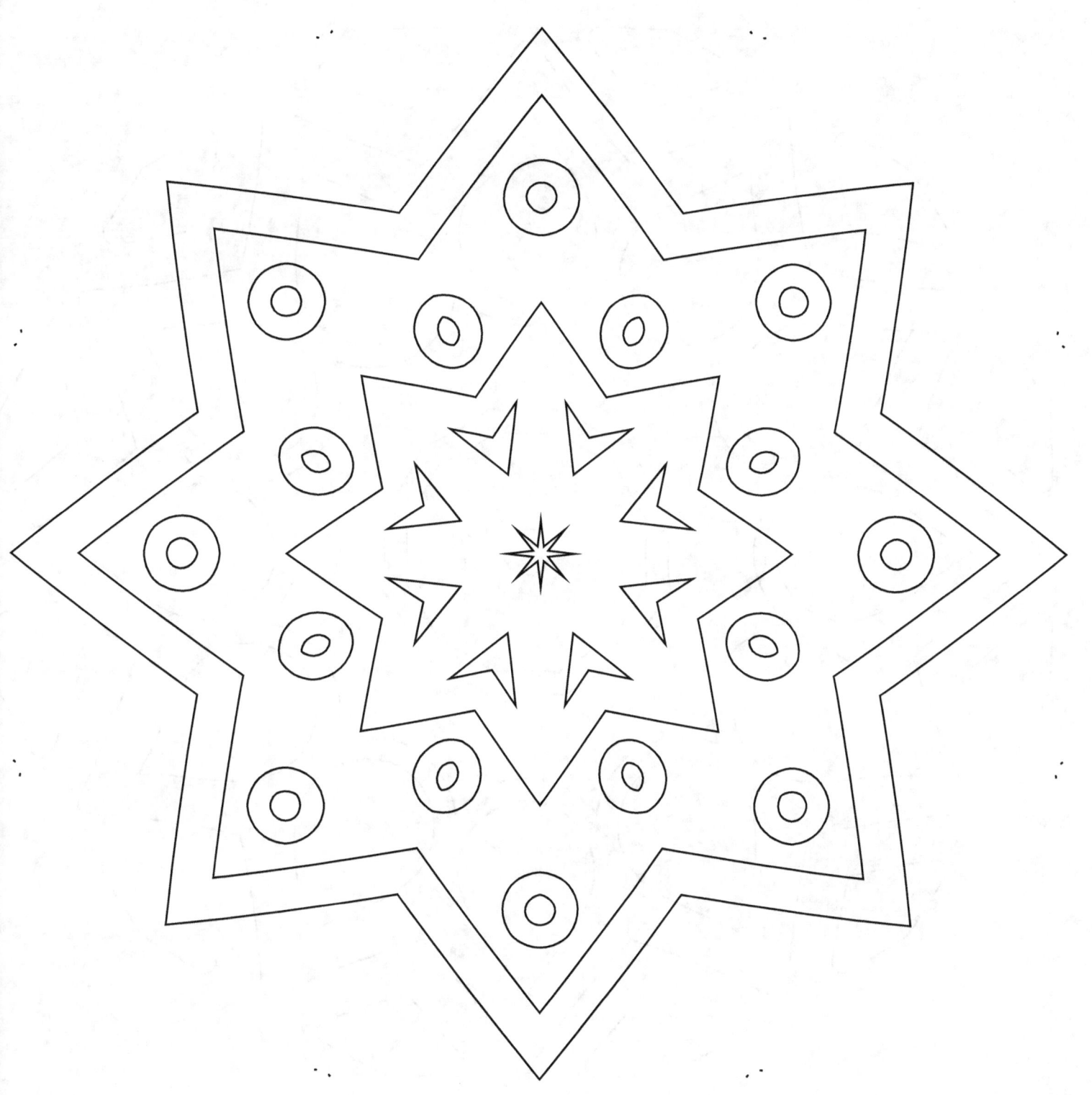

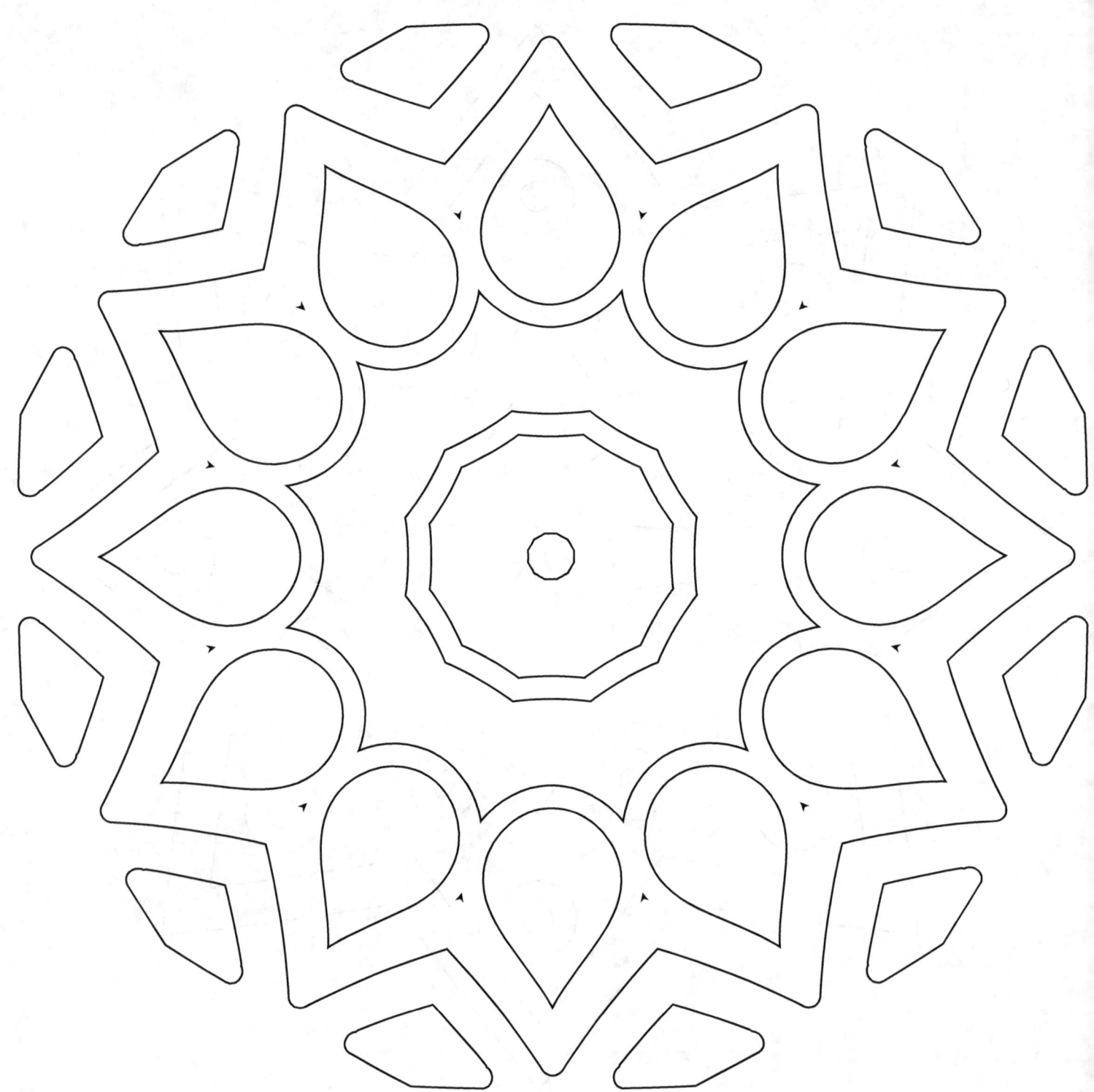

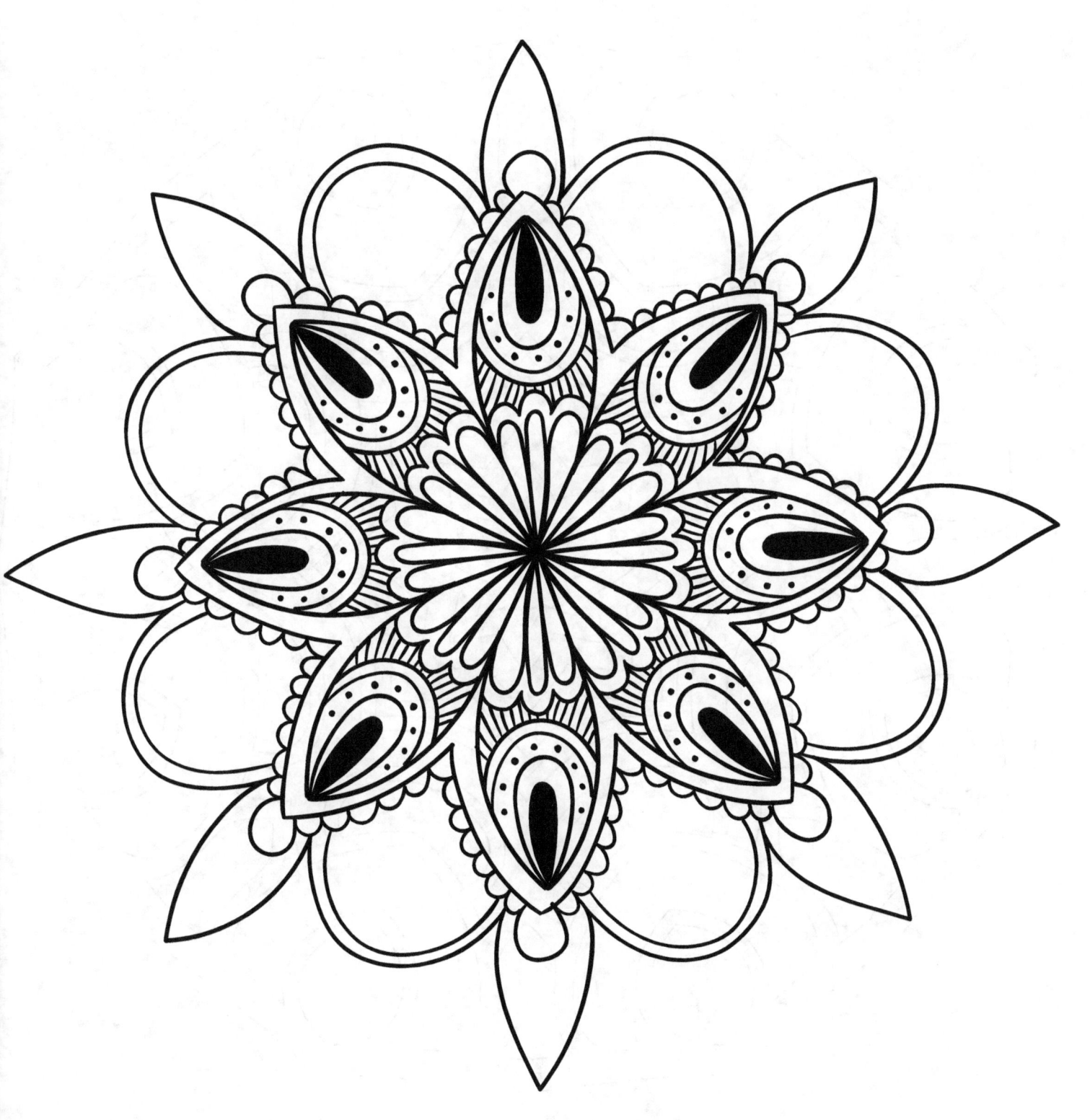

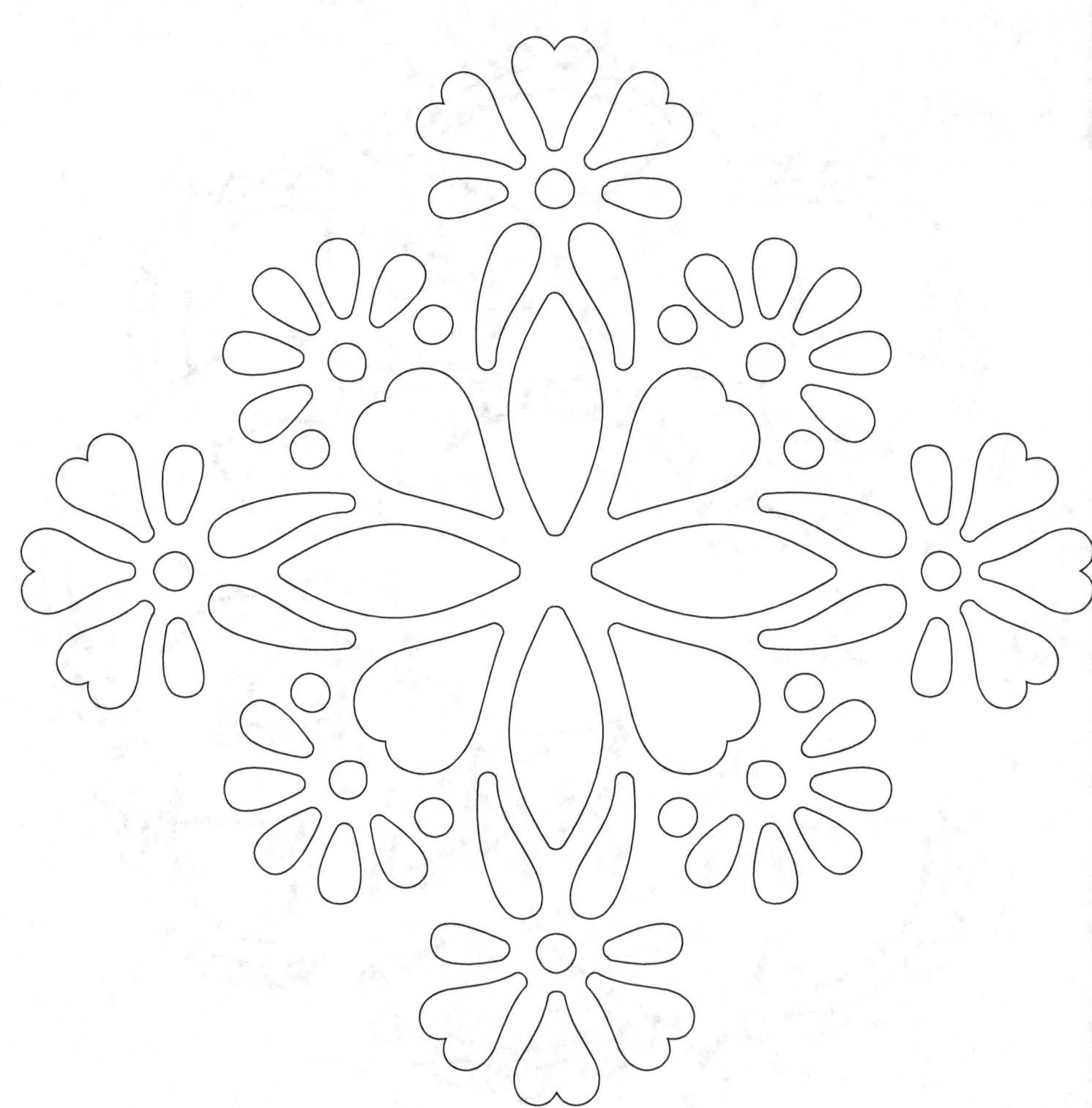

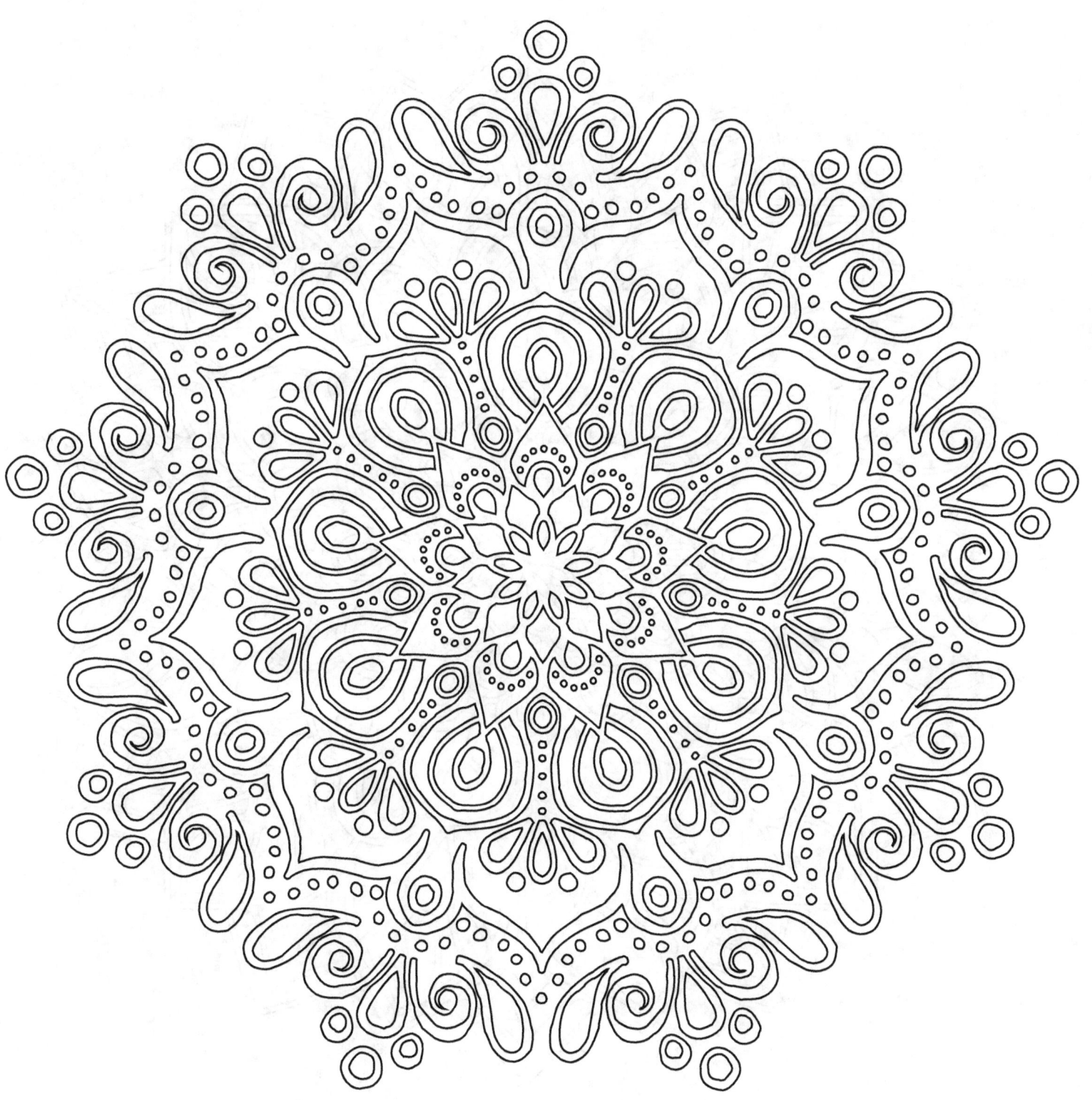

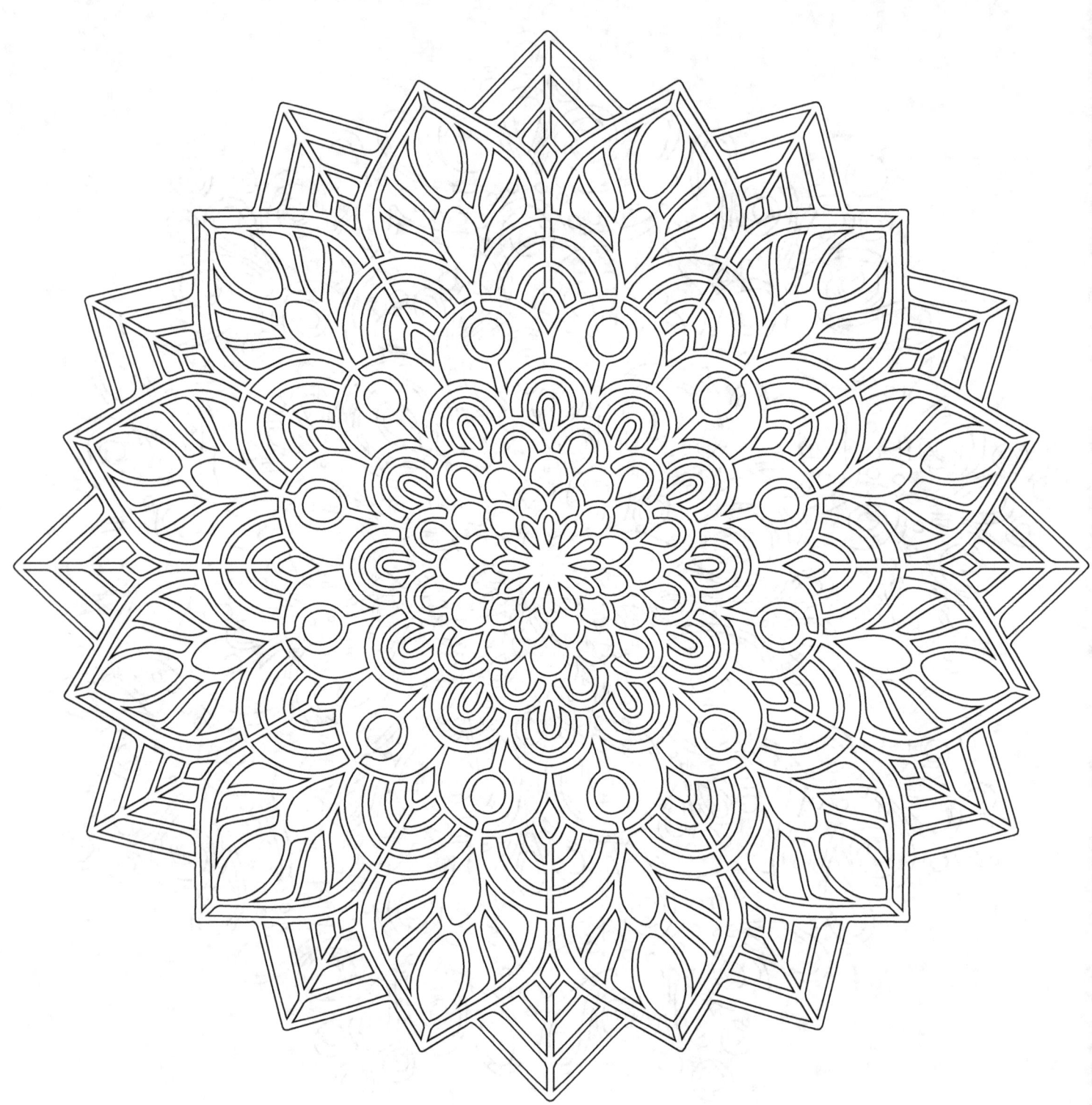

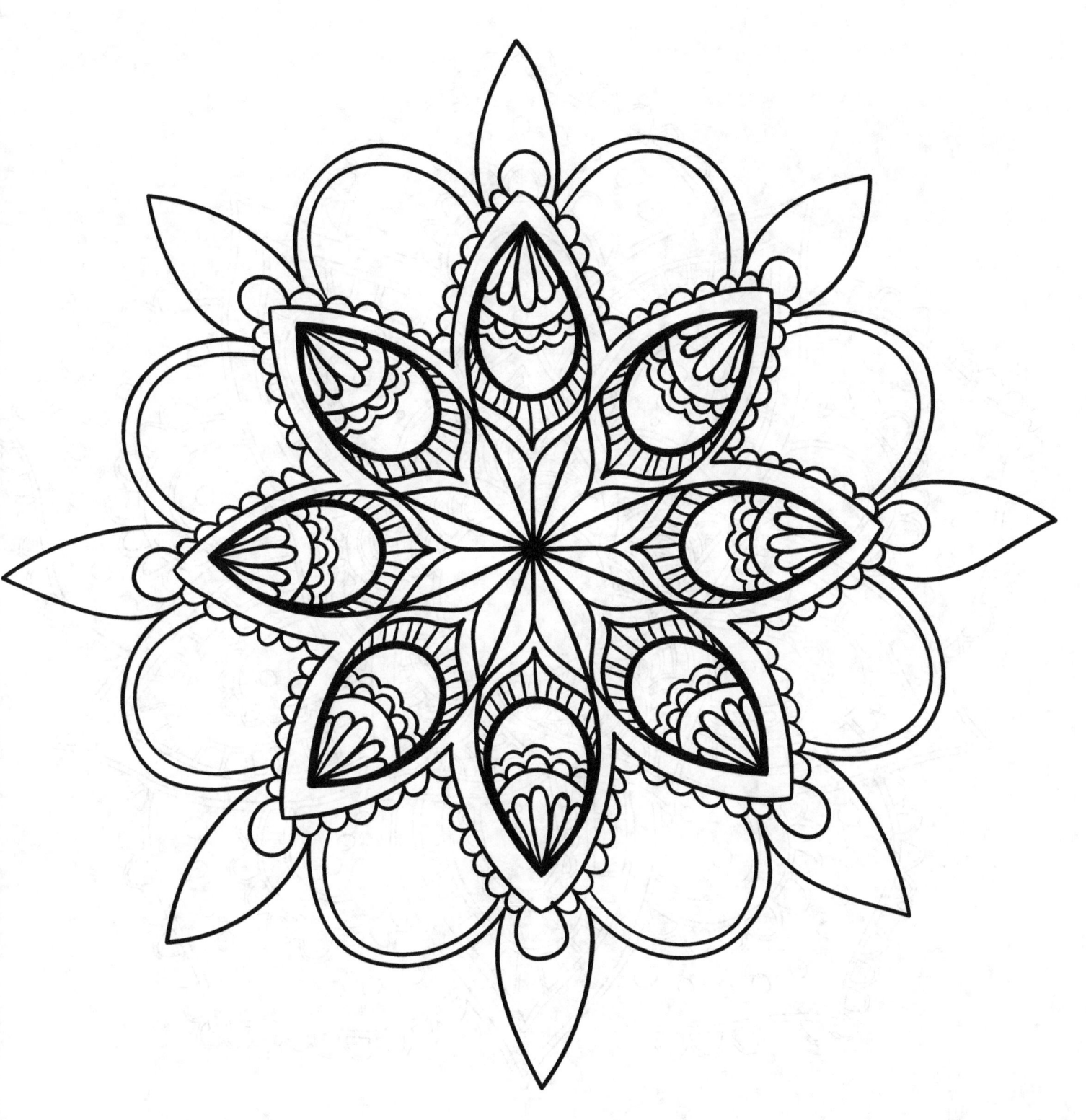

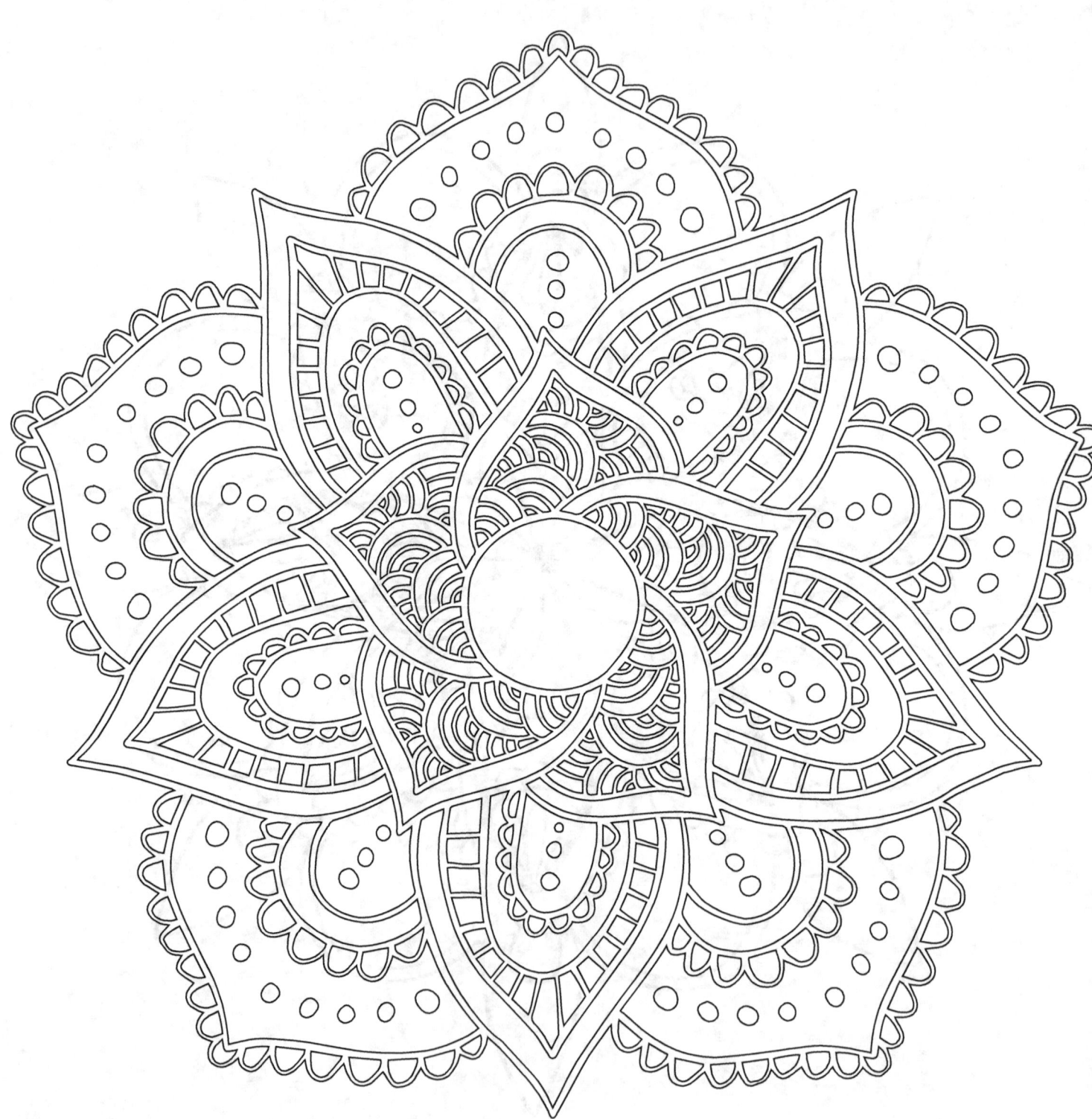

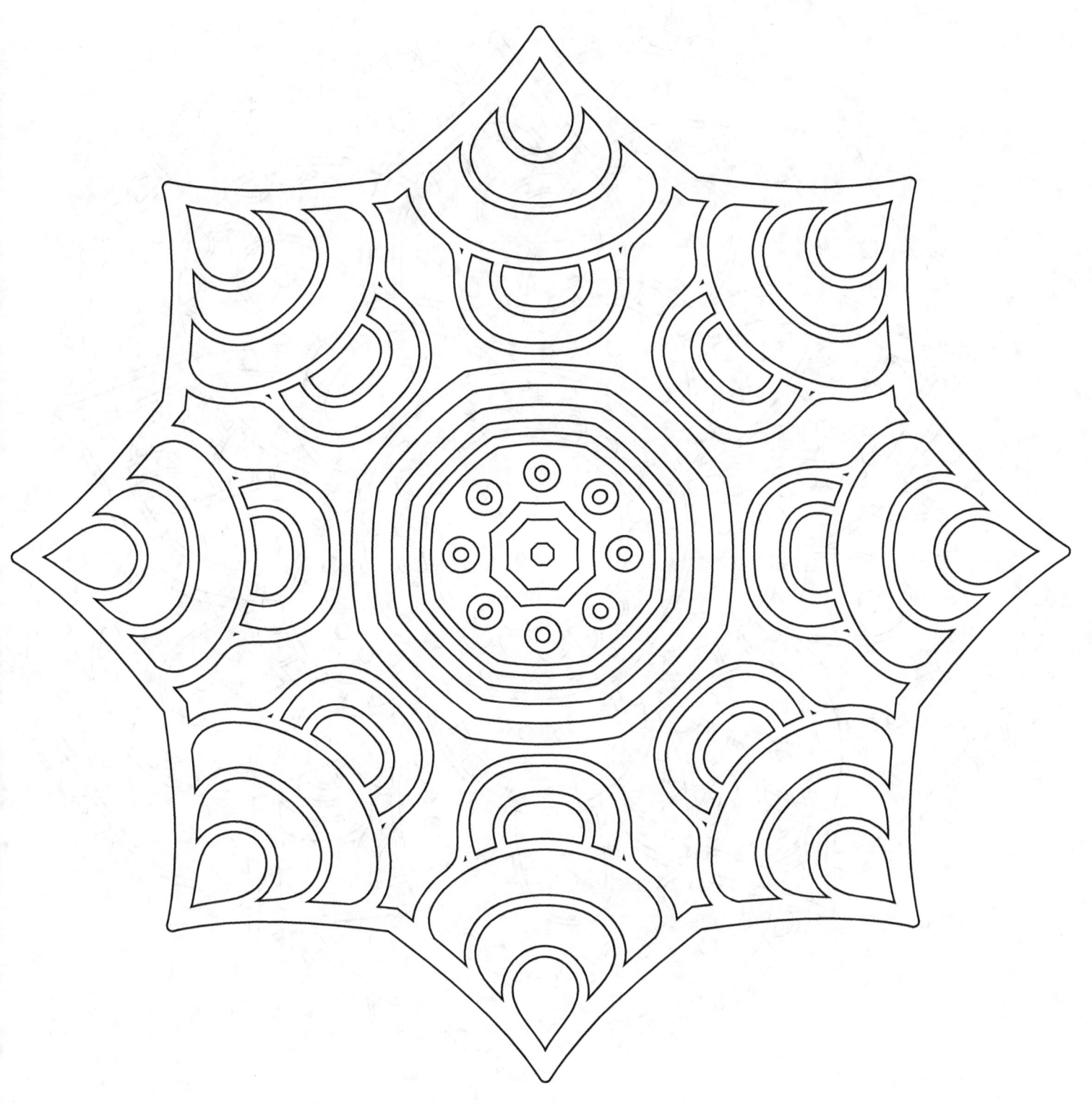

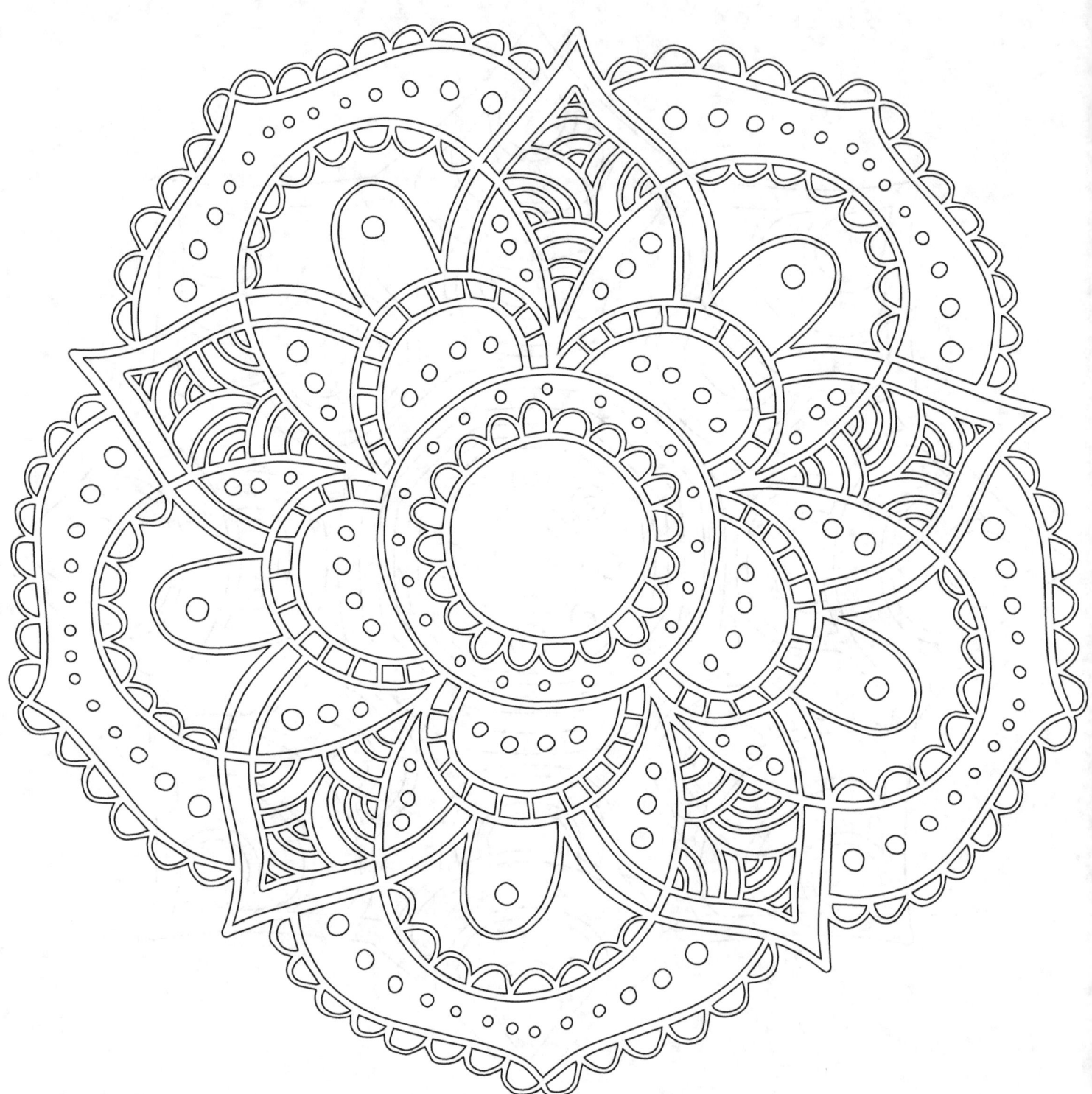

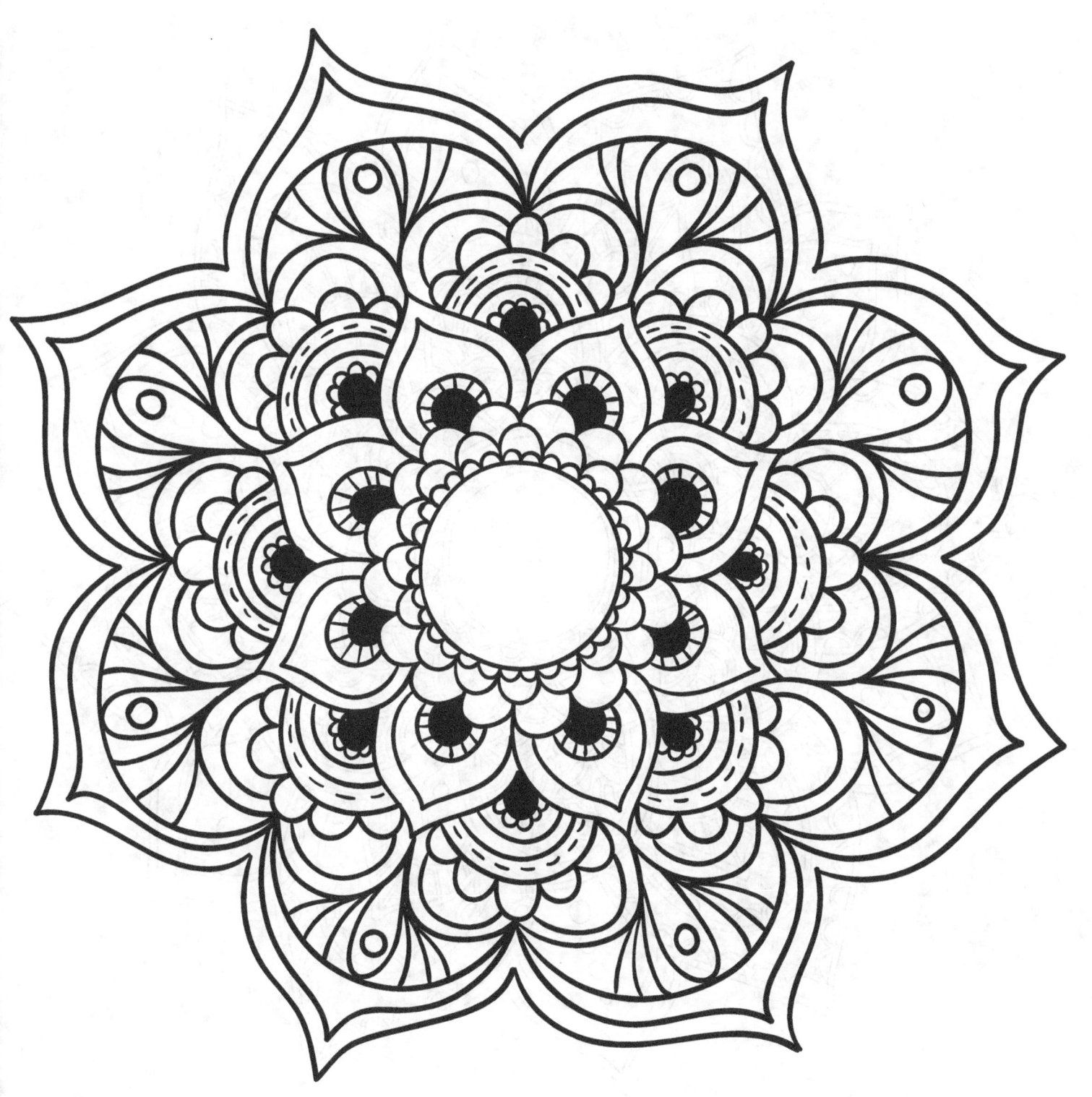

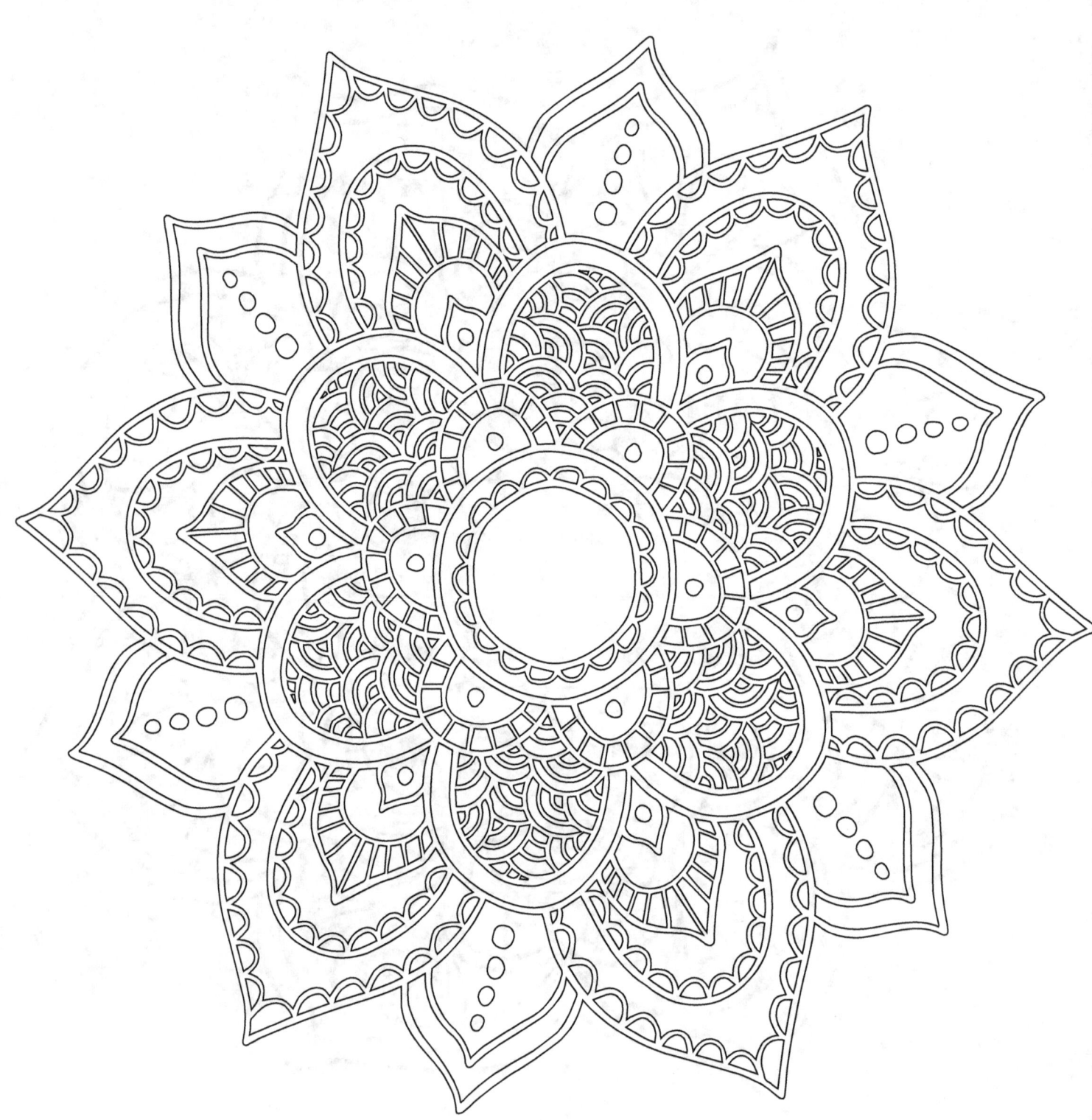

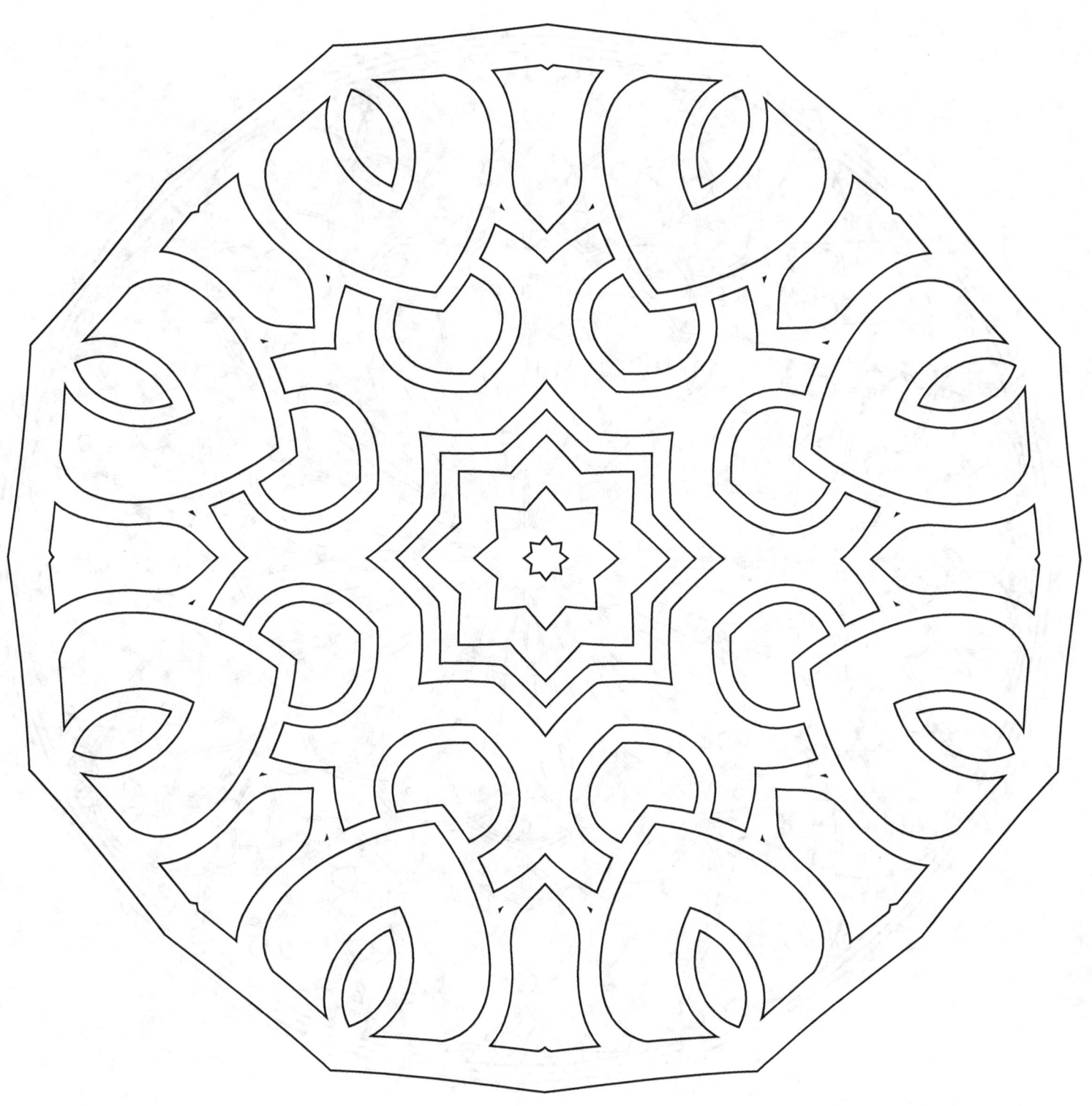

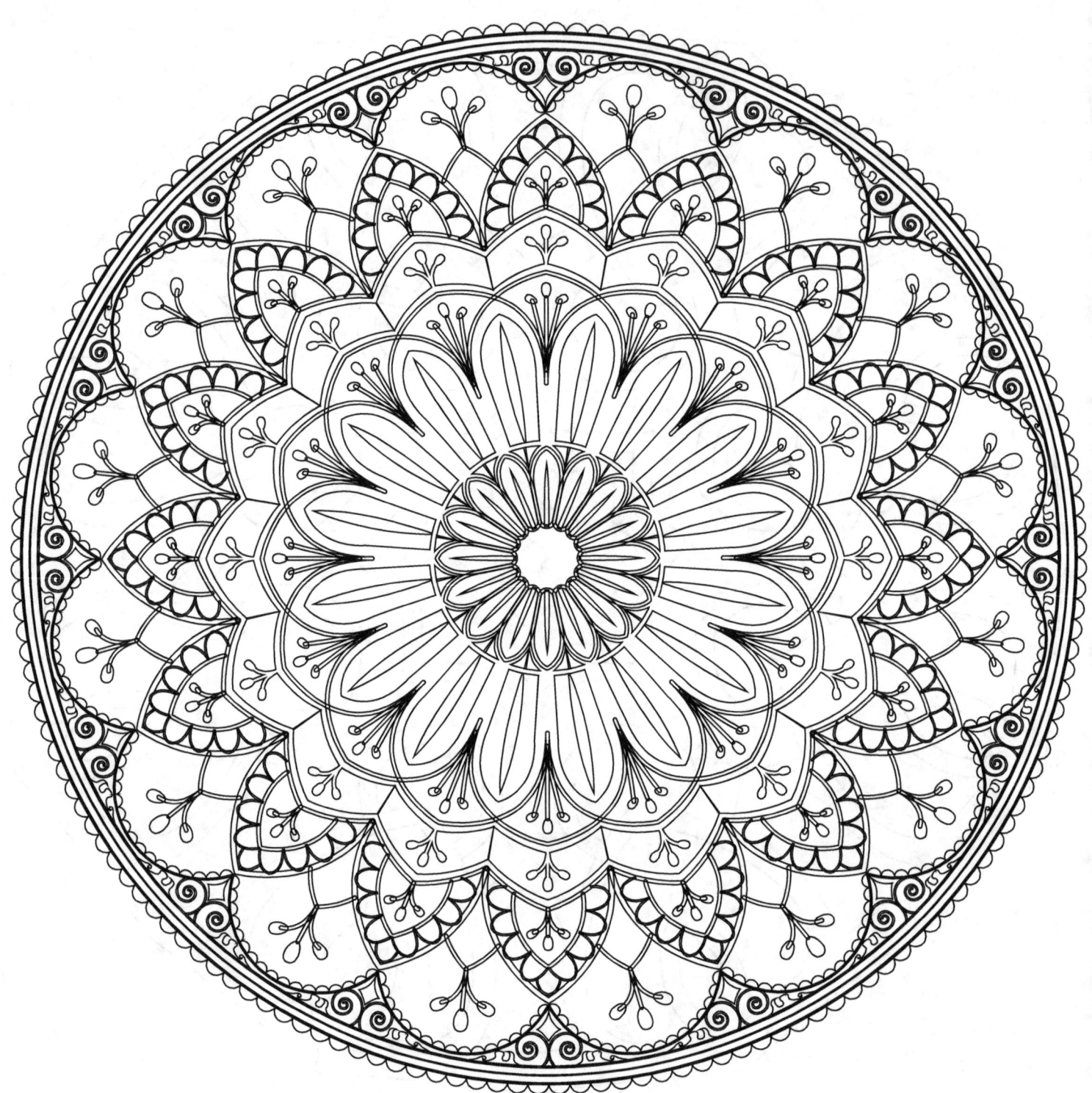

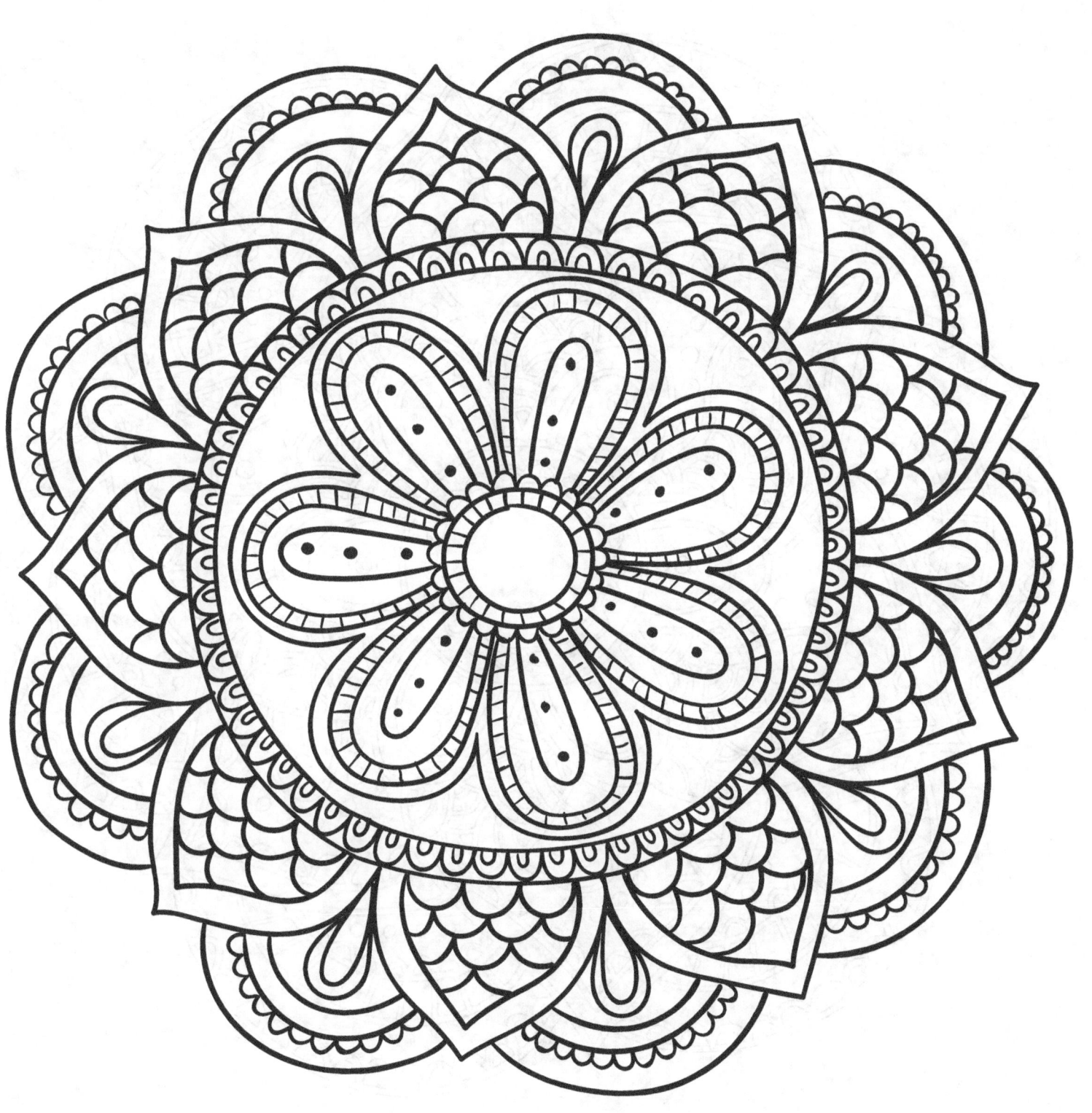

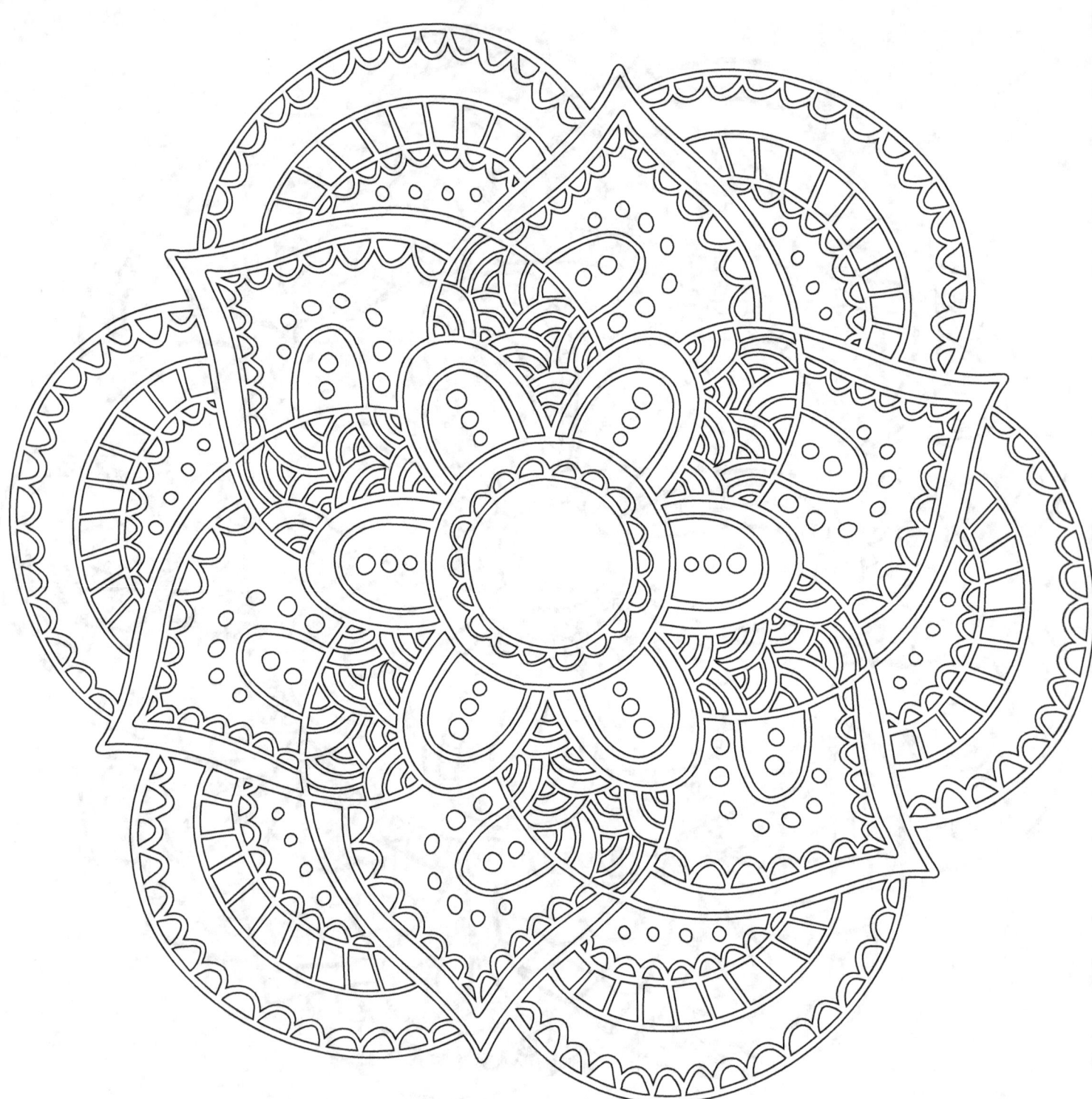

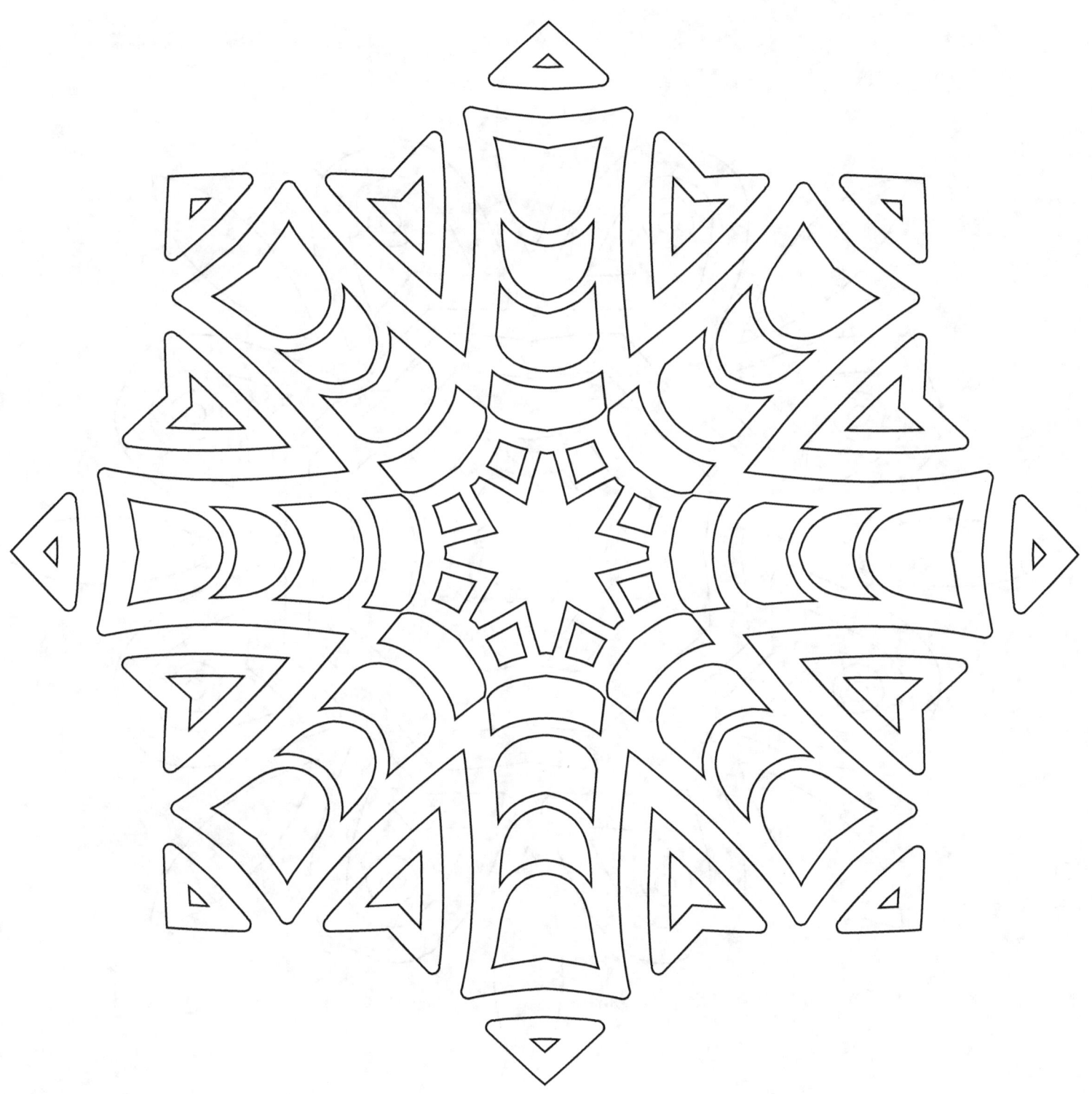

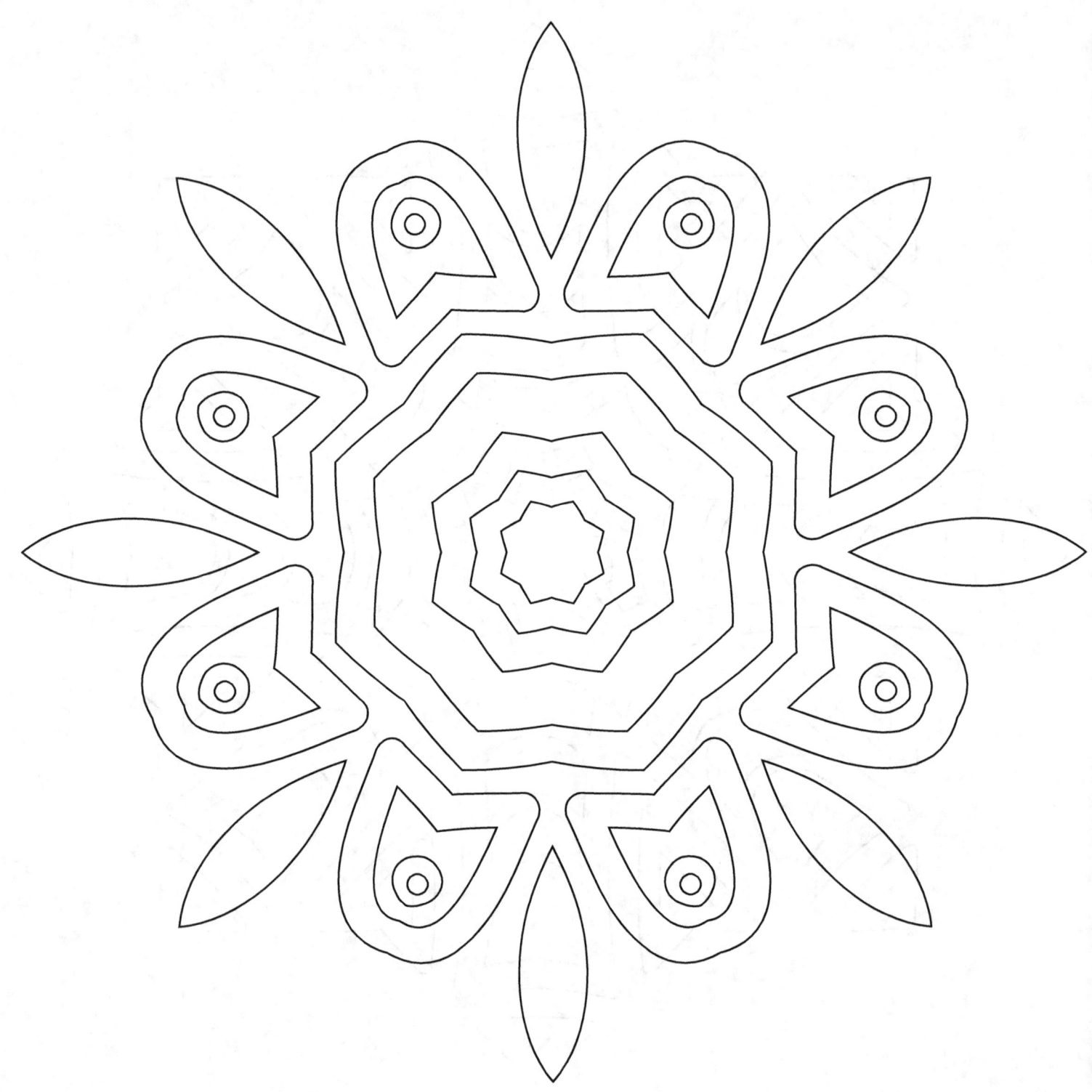

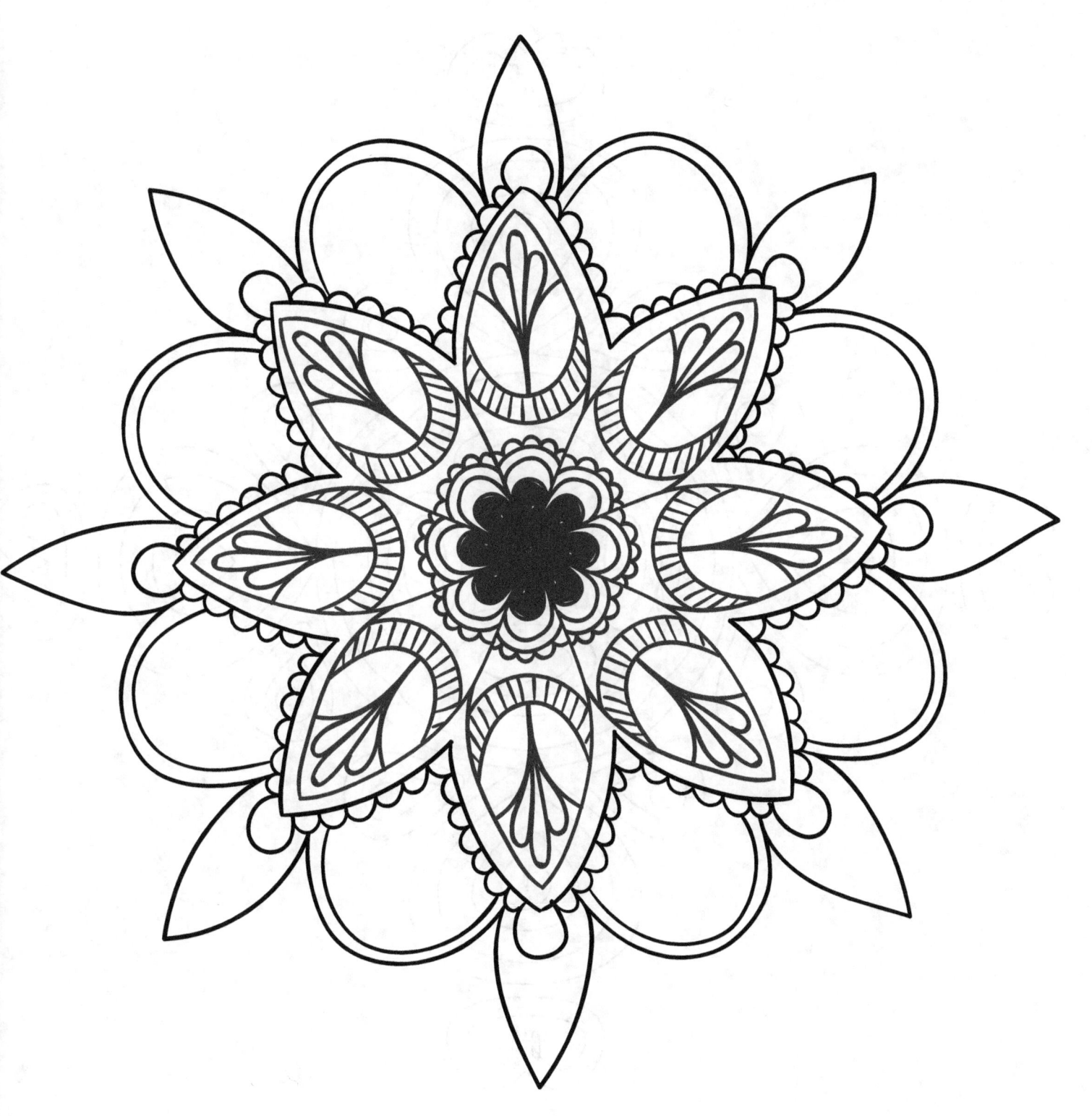

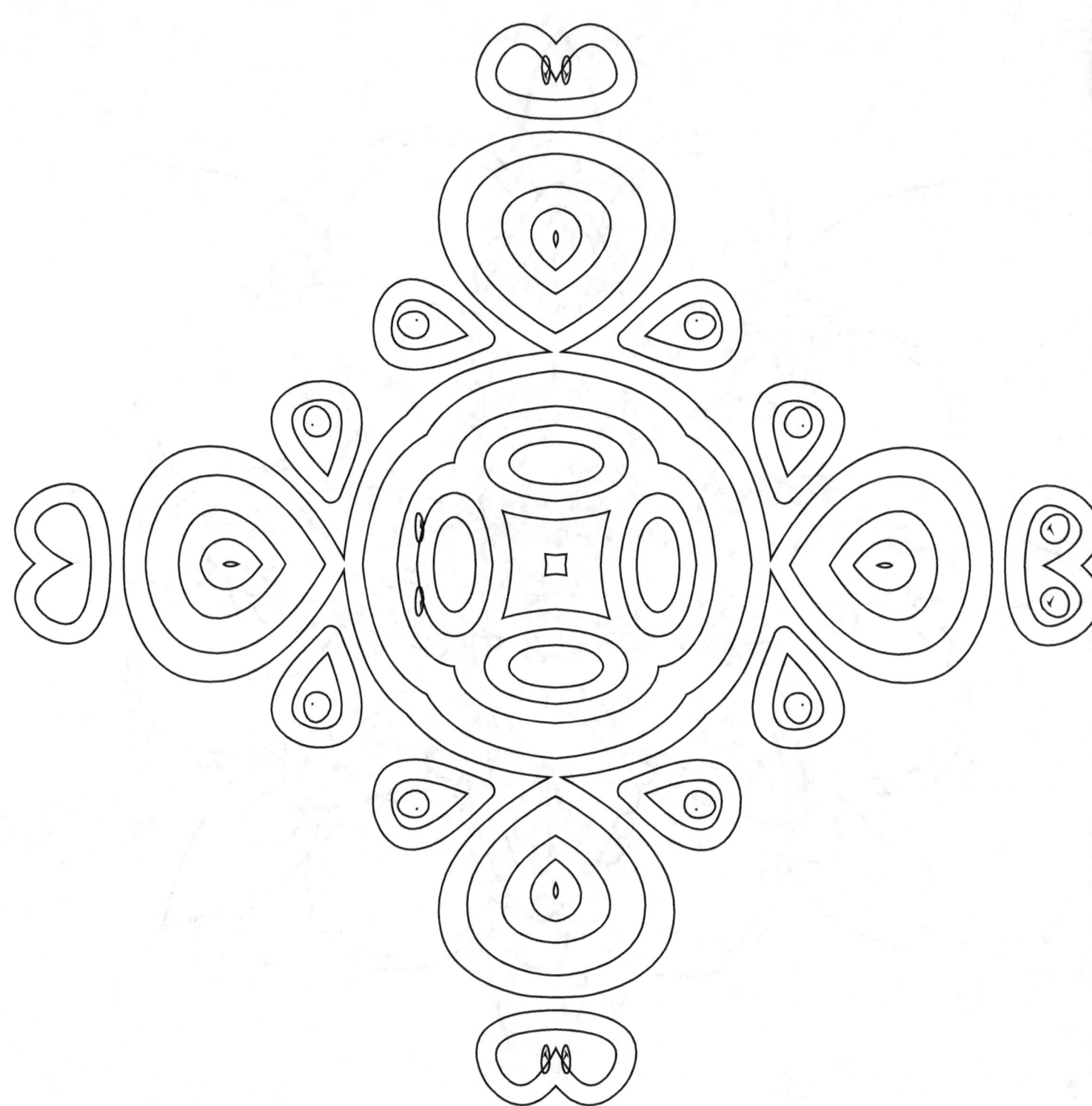

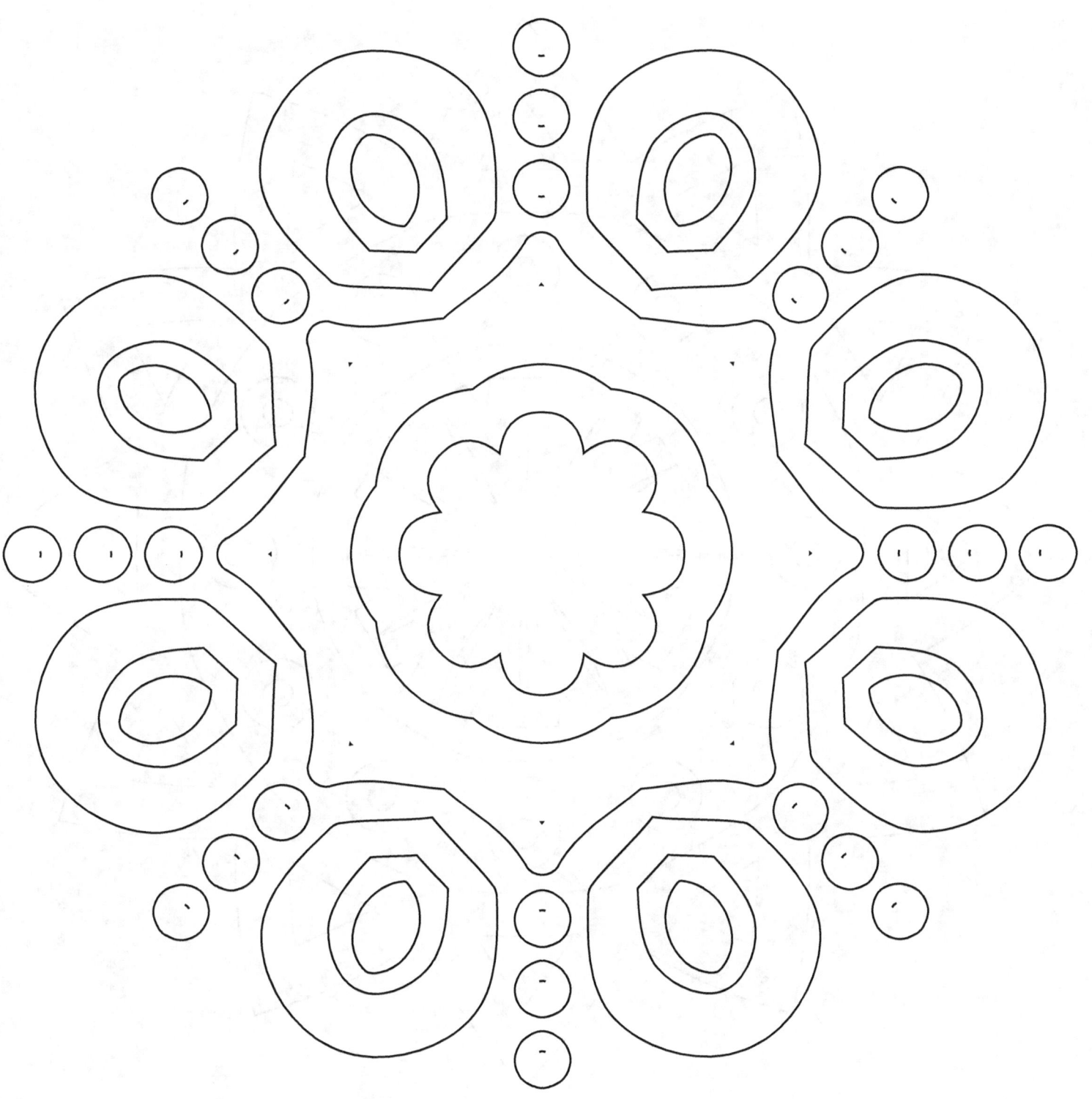

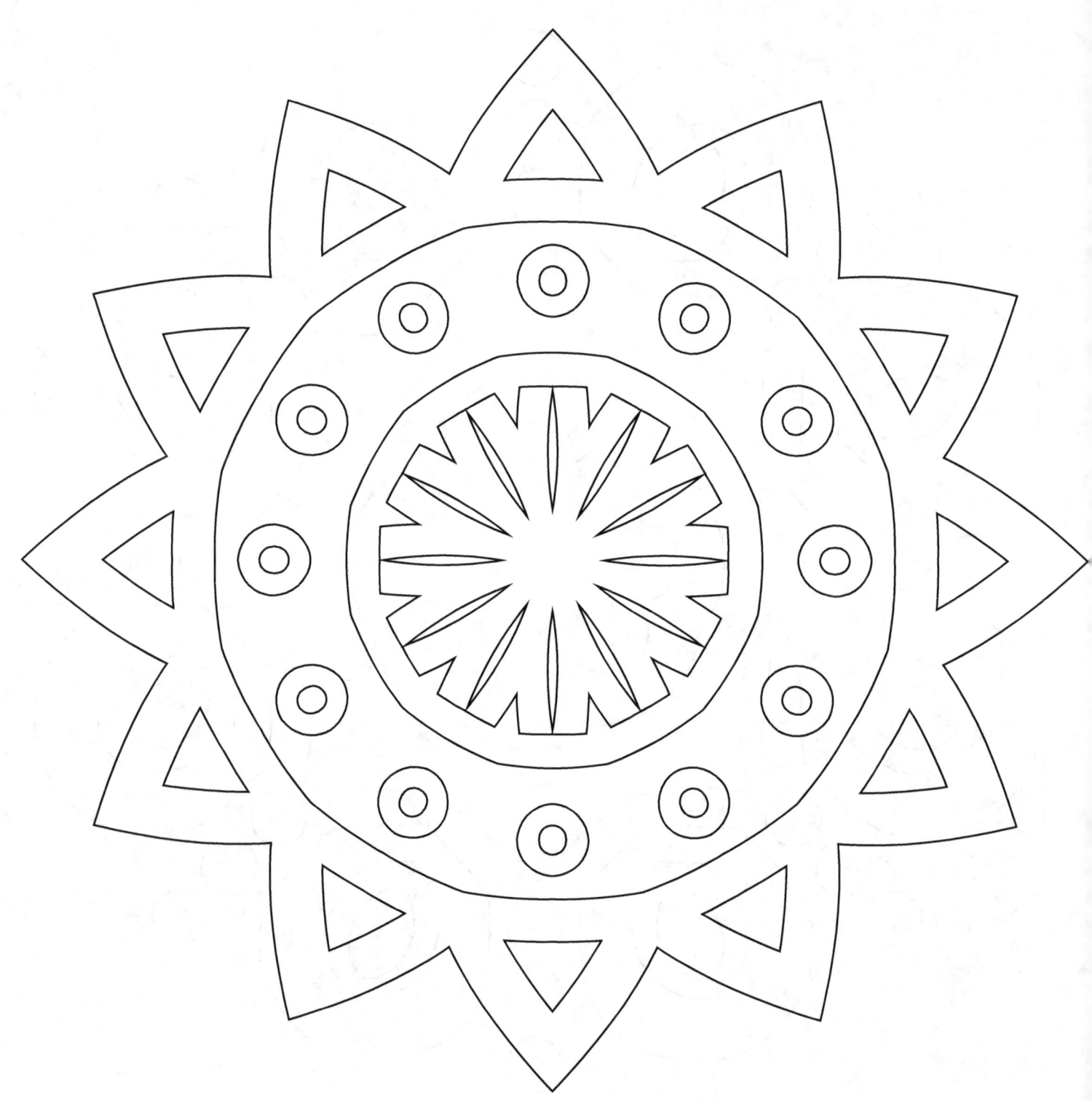

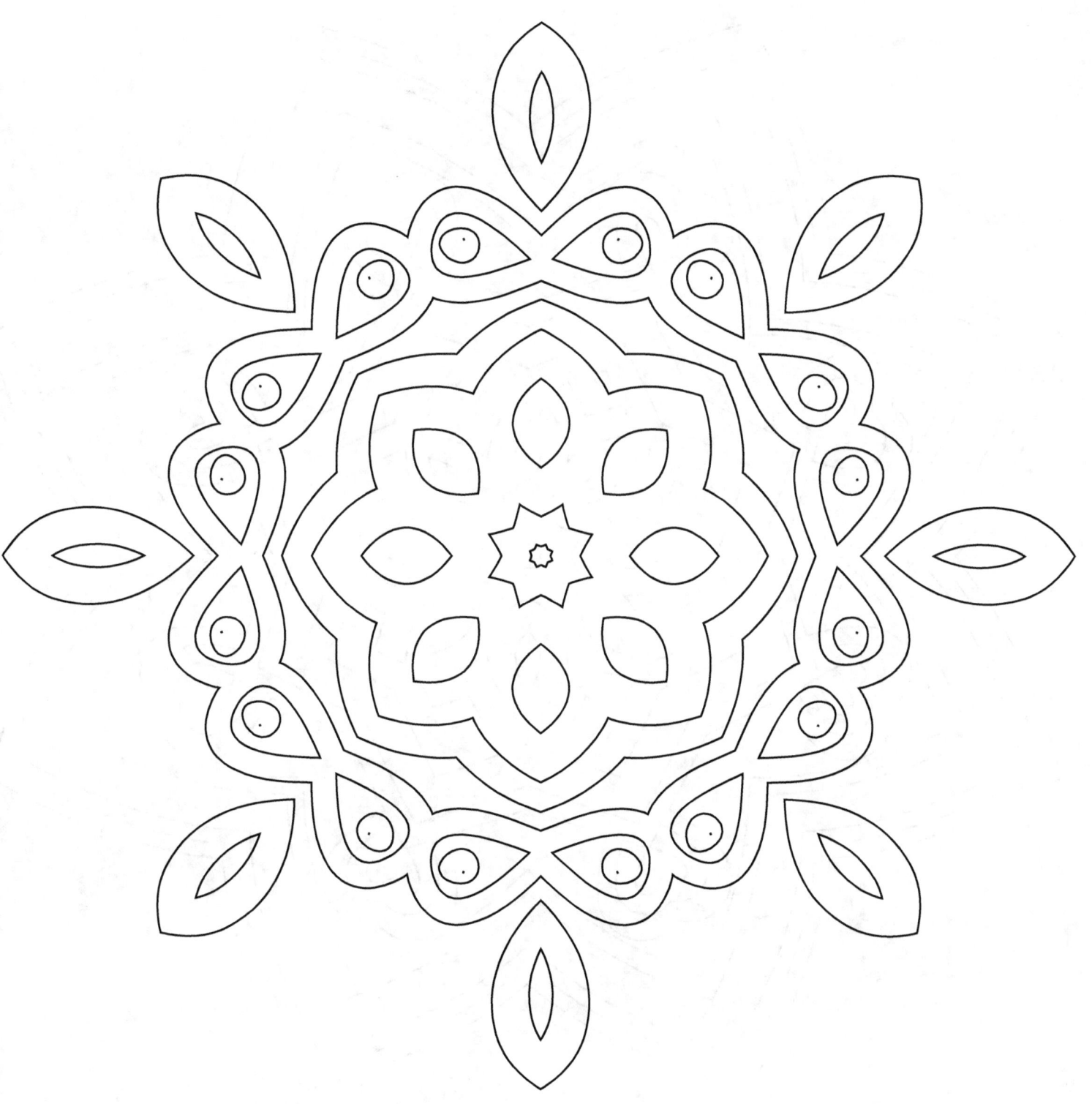

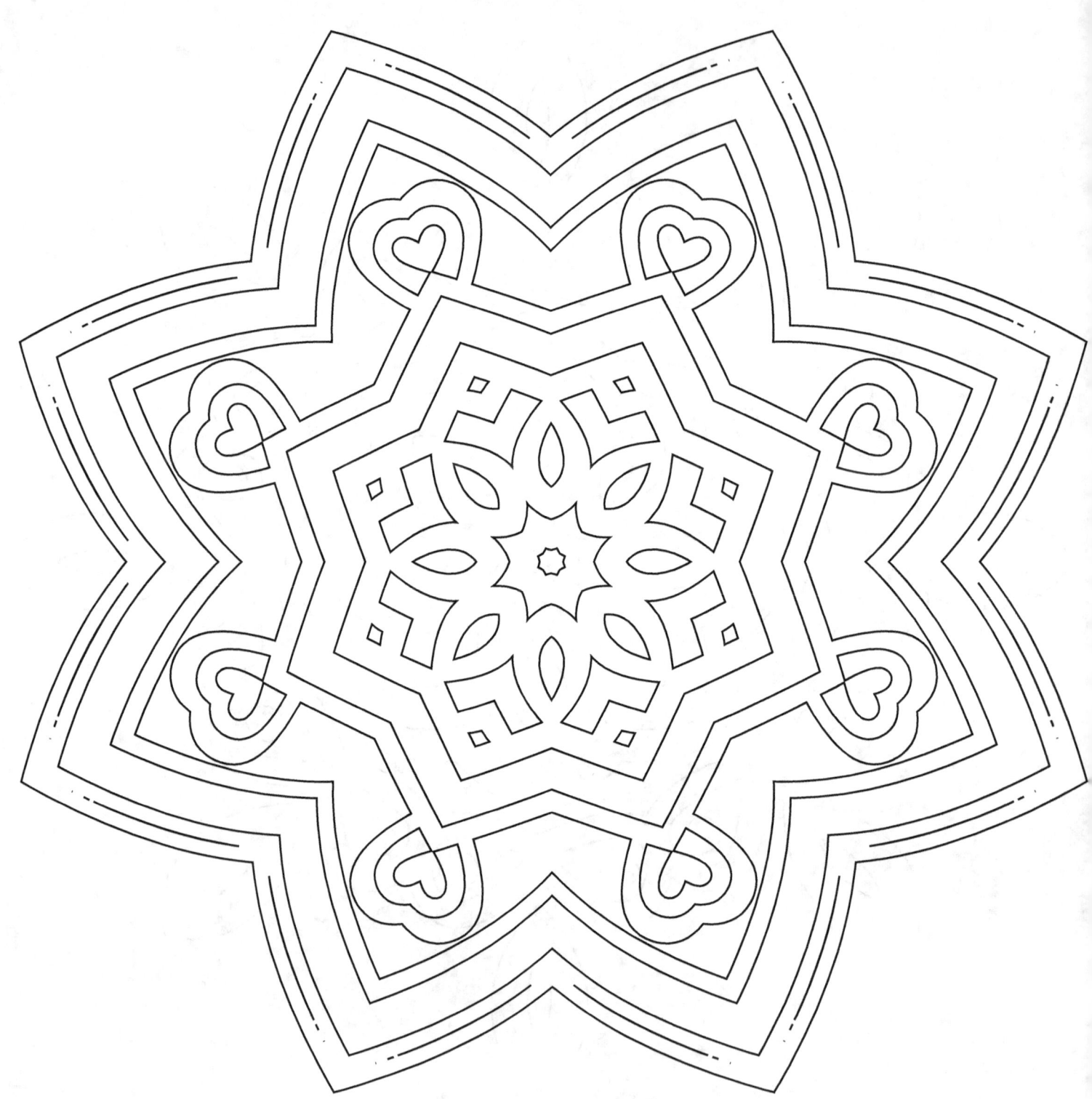

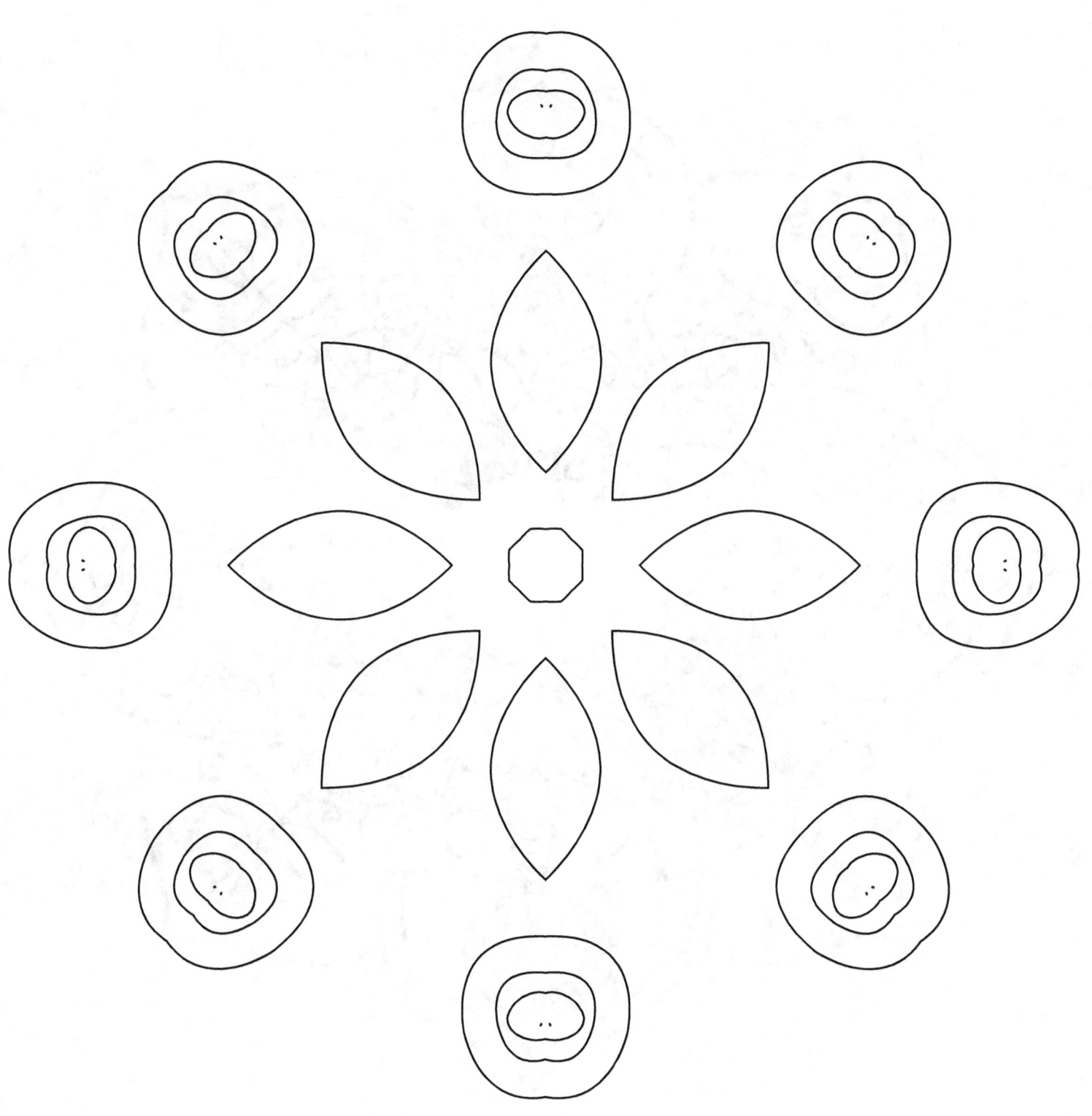

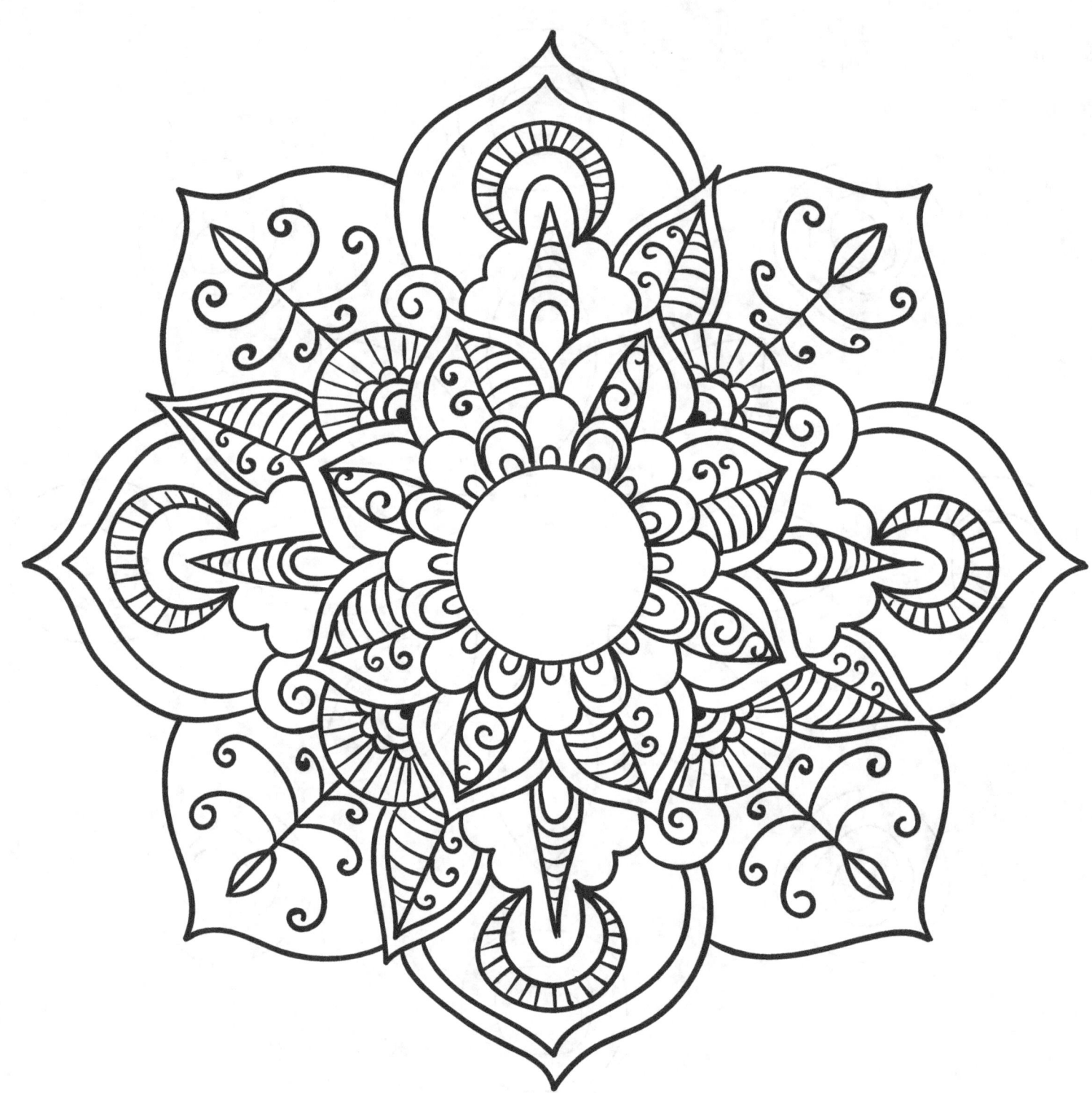

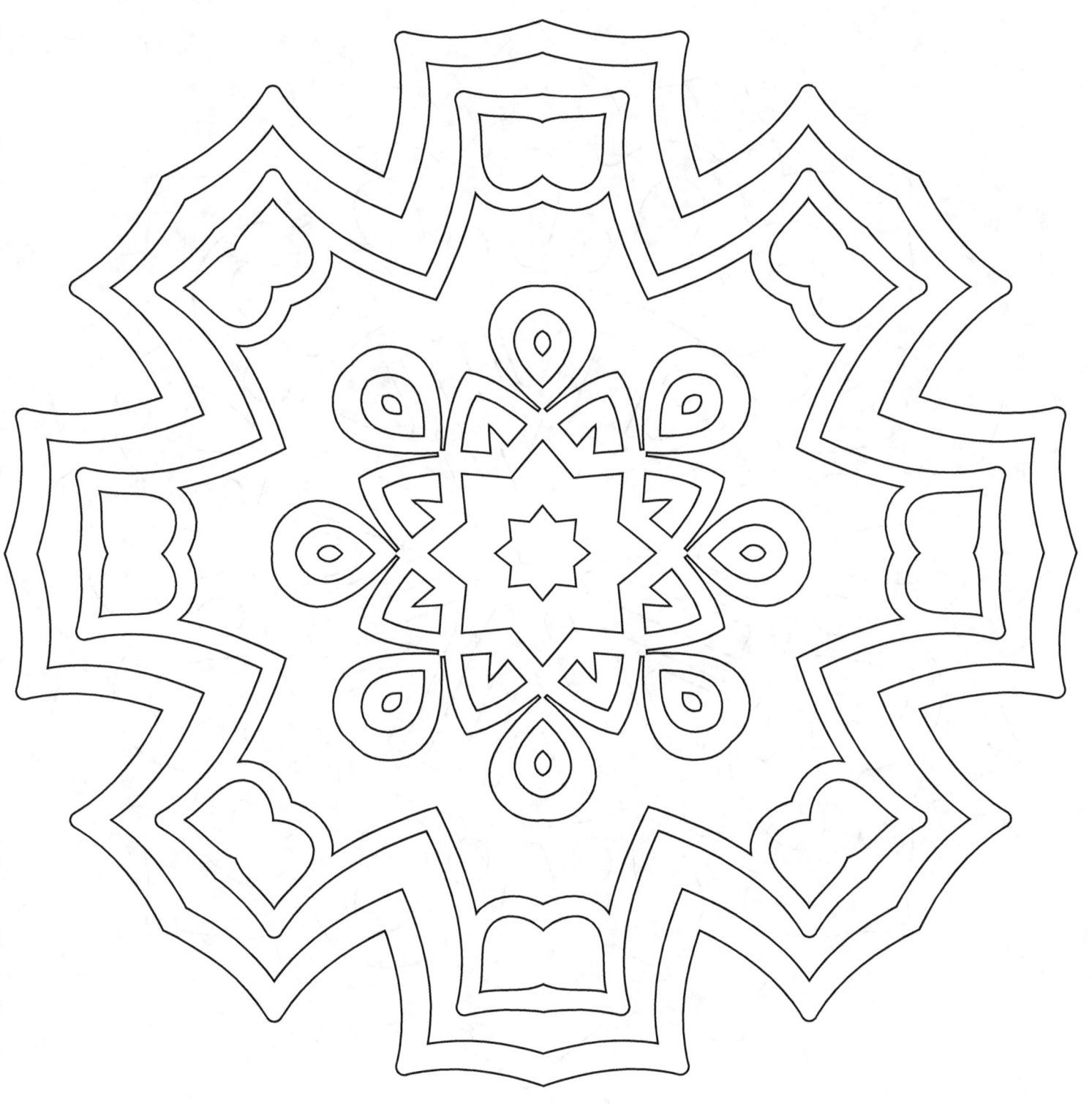

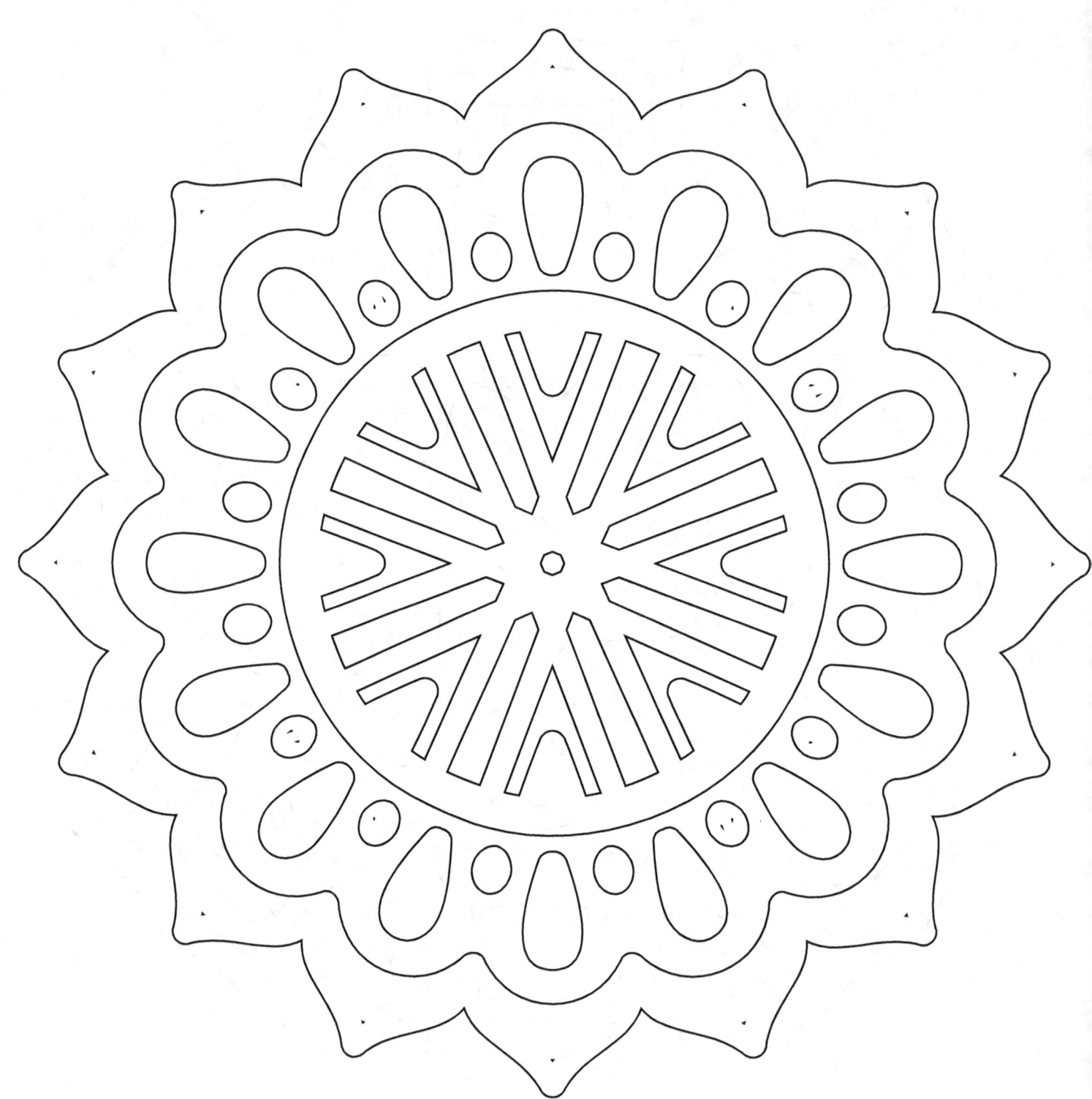

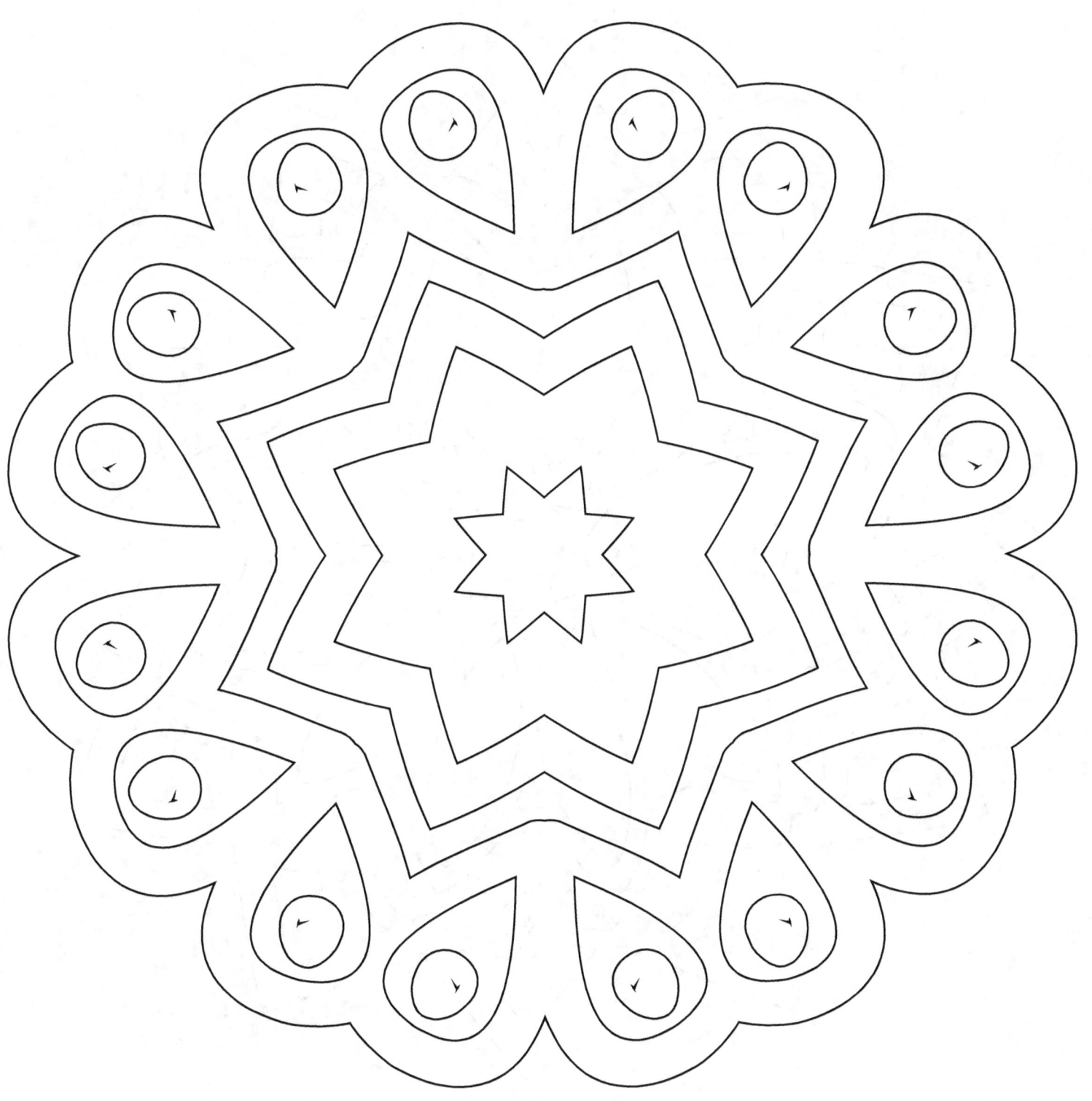

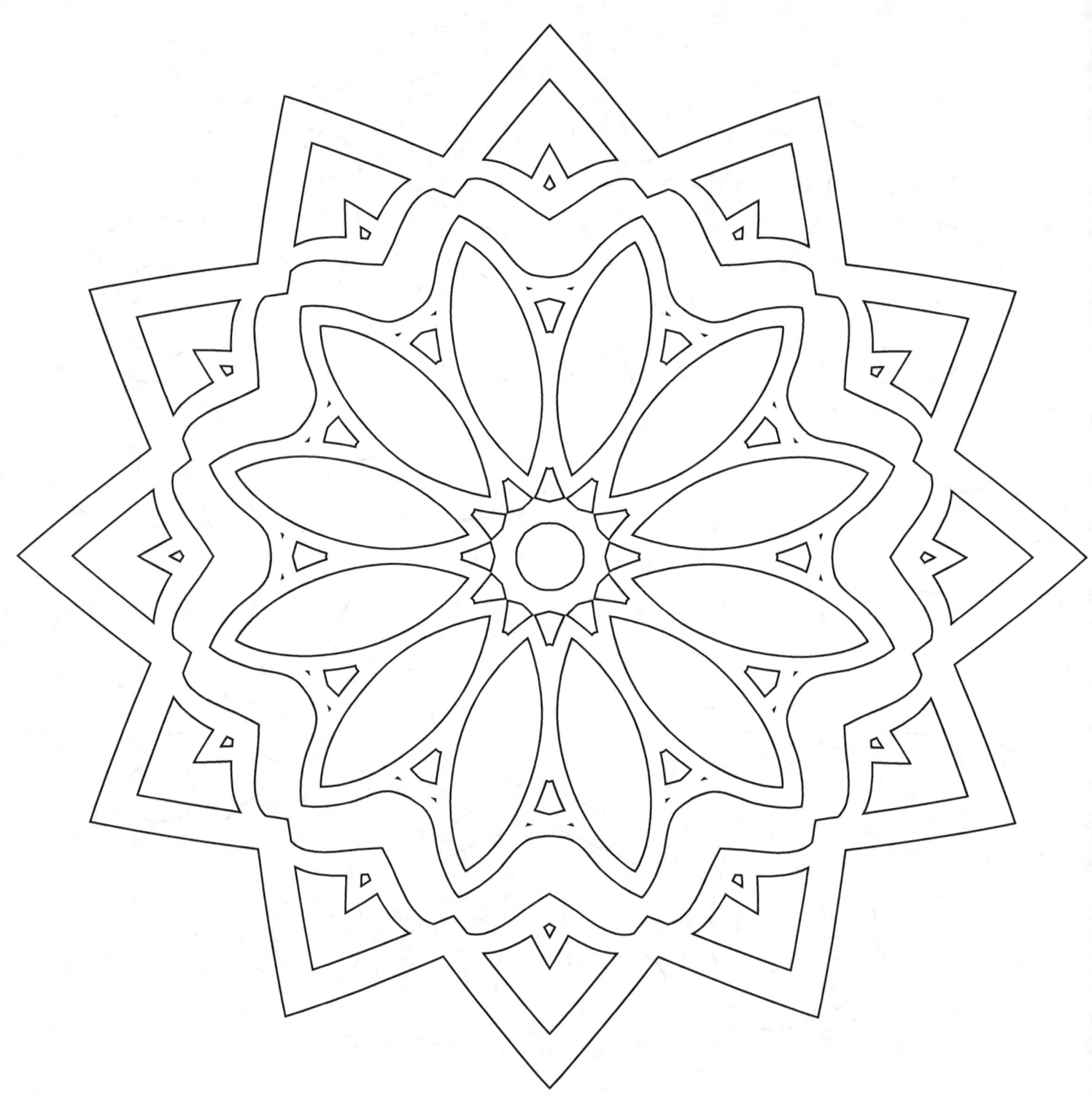

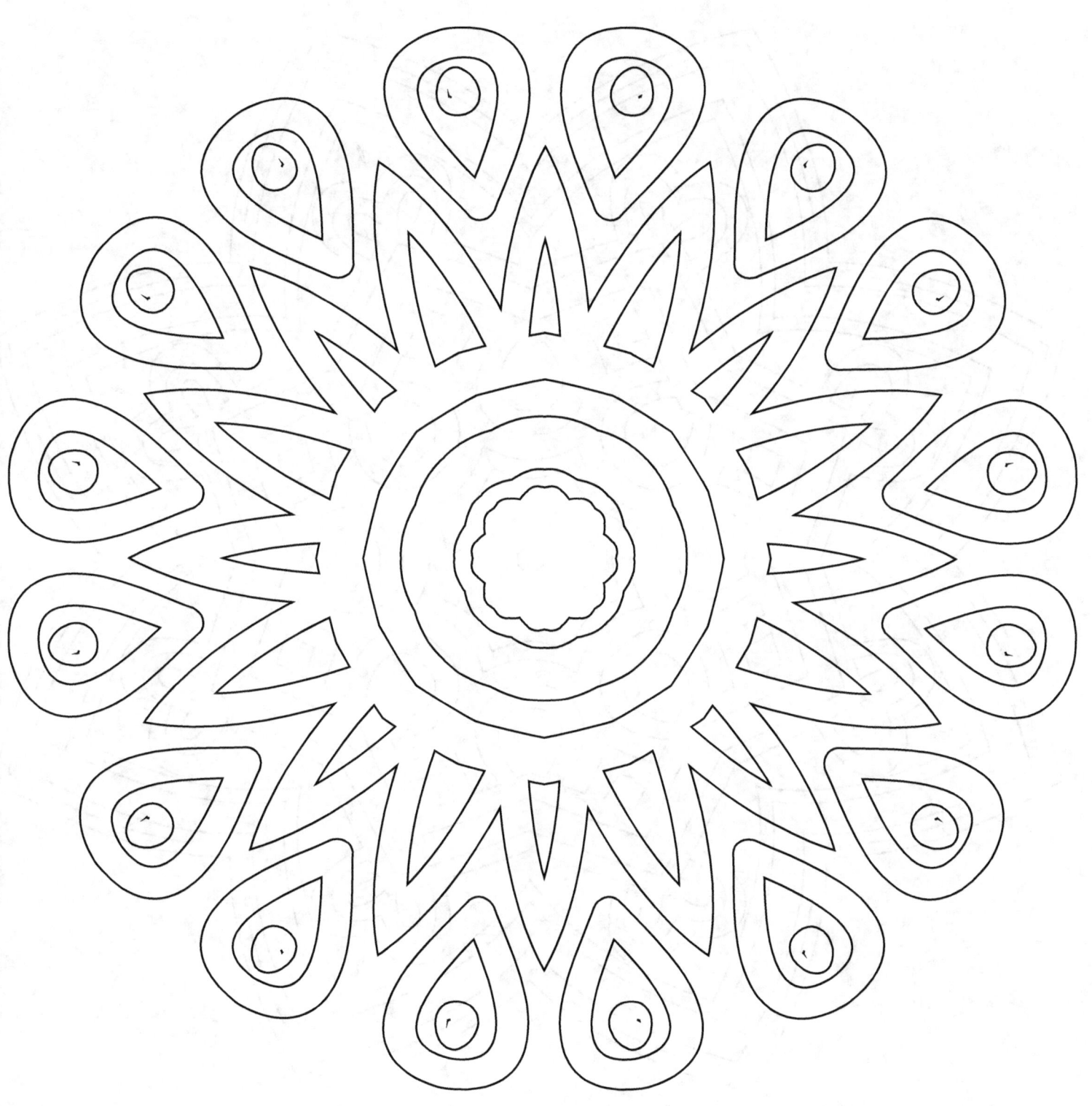

www.ingramcontent.com/pod-product-compliance
Lightning Source LLC
Chambersburg PA
CBHW080623220526
45466CB00010B/3441